# SAN DIEGO
## MURDER & MAYHEM

STEVE WILLARD

THE
History
PRESS

Published by The History Press
Charleston, SC
www.historypress.com

All photographs courtesy of the San Diego Police Museum unless otherwise noted.

First published 2018

Manufactured in the United States

ISBN 9781467138550

Library of Congress Control Number: 2018948033

*For Julie E.M. Willard*

# CONTENTS

# ACKNOWLEDGEMENTS

C redit is due to the following: the men and women of the San Diego Police Department, specifically the Detective Bureau, for their dedication, sacrifice and bravery, some of which will be narrated in the forthcoming pages; the staff, volunteers and supporters of the San Diego Police Museum—Jim Arthur, Richard Bennett, Rick Carlson, Randy Eichmann, Stan Elmore, Tom Giaquinto, Ed LaValle, Andrea and Jesse Meador, Mark Mendelsohn and Pat Vinson—for their preservation of the SDPD legacy; Carolyne Joseph for review; Neil Joseph for photography; Suzanne Russell for flow and content; and last but not least, the master, the man whose friendship has inspired my true crime writing, the world's bestselling police author, Joseph Wambaugh.

# INTRODUCTION

*The thin blue line of police is the only thing standing between anarchy and chaos.*
—*Los Angeles Police Department chief William H. Parker*

**R**egardless of the location in which police officers serve, the times we live in have made the job of an American uniformed patrol cop perhaps the most high-profile profession in the United States. Admittedly, it takes a special person to try and an even more unique person to walk the blue line day in and day out. That said, there exists a crucial element of American law enforcement often overshadowed by their more visible counterparts; they are the plainclothes detectives of "The Bureau." These skilled men and women seldom wear uniforms and rarely drive marked police cars. Their work is better suited behind the scenes, in the shadows of the thin blue line, as they piece together clues, common sense and physical evidence to solve cases and deliver justice.

Twenty-five of my thirty-three-year career has been spent in the Detective Bureau of the San Diego Police Department. So when I had the opportunity to deliver a narrative of San Diego crime, I wanted to do it from their perspective.

The cases are real. The cops are all true-life characters who once served the SDPD. Only in the cases of sexual assault have the names been changed to protect the innocent.

The information presented is derived from police reports, museum archives, newspapers and memoirs. Some creative licensing, such as

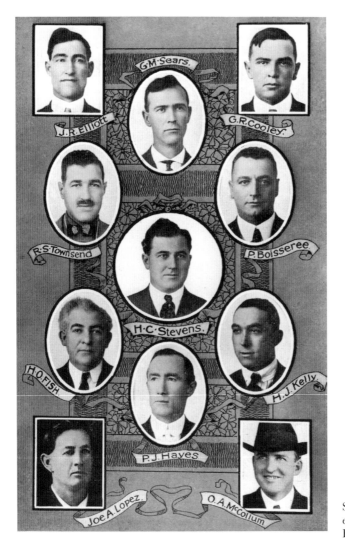

SDPD's small but efficient Detective Bureau, circa 1918.

dialogue, attire, mannerisms and other minor elements, was taken to provide the reader an immersive experience in what it was like to fight crime in the Roaring Twenties era of American justice.

# DEATH OF THE STINGAREE

**A**lmost a century before the Gaslamp Quarter became San Diego's trendy tourist district of shopping, dancing and fine dining, it was filled with as much debauchery as the vice-ridden Barbary Coast of San Francisco. That is, until San Diego's most innovative police chief said, "Enough."

SUNDAY MORNING, NOVEMBER 10, 1912: Plainclothes bureau men and uniformed patrolmen of the San Diego Police Department swarmed the Stingaree District—a notorious neighborhood of opium dens, brothels and saloons that served thirsty sailors in port as well as local residents drawn to sin.

Armed with rifles, warrants and a personal directive from Chief of Police Jefferson "Keno" Wilson, the cops began kicking down the doors of every known brothel, some of which had been open as far back as 1885. The women were hauled to the curb in shackles to be transported to police headquarters. The horse-drawn prisoner wagon had a ten-passenger limit, forcing many officers to walk the women to the police station. Newspapers later recalled, "If one lagged behind or threatened to bolt, an officer would blow a whistle and shake his billy club at the offender. There was not a single case of resistance or protest," wrote the *San Diego Union*. "The women laughed their way to the station good naturedly. They treated the round-up as a joke."

By the end of the raid, SDPD had arrested 138 prostitutes, at least half under age seventeen. Not a single "John" was arrested. Prostitution in those days was strictly a female crime.

For the next seven hours, Chief Wilson, Deputy City Attorney D.F. Glidden and an immigration officer interviewed the women one at a time in the chief's office. A dossier was created for each arrestee, including their names, dates of birth and where they were from. The most important question was would they reform or leave San Diego the next day?

Many of the women gave their last name as "Doe." The younger ones claimed they were born in 1888 so they wouldn't be arrested as juveniles, though about 70 percent were between thirteen and seventeen years old. The chief estimated at least nine-tenths of the women had come to San Diego within the last six months due to L.A. closing its red-light district.

Telling the women to leave town proved to be a temporary solution. If the problem was going to be eradicated, the opium dens and brothels needed to be closed forever.

Keno Wilson closed the Stingaree and then diversified the SDPD in an era when society didn't want it. His integrity and innovation eventually cost him his job.

1915: As PREDICTED, THE 1912 Stingaree sweep was a temporary fix to a much larger, more complicated issue. For the women who refused to leave town, the chief watched the criminal cases fall away when local power brokers, many of whom either frequented the Stingaree brothels or owned a stake in them, began leaning on local prosecutors to drop the charges.

Something else needed to be done, and Keno Wilson had the guts to do it.

In 1909, Wilson had just taken office as chief when he made a bold decision: he hired Frank McCarter as a special patrolman. Today, the appointment of a black officer wouldn't raise an eyebrow. In 1909, it was huge news and not welcomed by a large swatch of the local population.

Several years later, Wilson again made waves with how he responded to complaints about signs in some local restaurants. Leaders in the black community were upset with signs banning them from some of the finer eating establishments. Keenly aware of the First Amendment of the U.S. Constitution, the crafty chief instead enforced an obscure ordinance related to the size of signs and how they were placed on the building. While not as

dramatic as ripping down the offensive signage, the end result was the same: the signs were taken down.

Reginald S. Townsend was SDPD's second black employee and first black detective. As an African American man in the early twentieth century, he knew there was little chance of finding work as anything more than a laborer or pipe fitter. He also knew that even if the SDPD welcomed him, many local citizens did not. So when the chief of police personally summoned him to his office and said, "I have a special task for you," Townsend was eager to prove himself. The assignment was simple: Townsend would serve as bodyguard to Health Inspector Walter Bellon and clean up the vice-ridden Stingaree once and for all.

Chief Wilson had long given up on hoping that local courts would close down the brothels, so he shifted gears. He went to the California state attorney general and requested that a health inspector enforce state health code laws—something city leaders had no control over.

By the time Townsend and Detective Walter Weymouth were paired with Bellon, the inspector was regarded as the most hated man in San Diego. Bellon had already tried to close down the seedy district, but the barrage of death threats inhibited his success.

Even Bellon felt the pressure: "Things began to get real hot.…Time was running out if they didn't pull me off. The waterfront supported some tough characters and my hide was going to be stretched, then tanned."

After the demise of the Yankee Doodle and Pacific Squadron saloons—a strike at the heart of the Stingaree—the health department began receiving enough phone threats and hate mail to concern Chief Wilson. One morning, Bellon found two very large men in his office. The goons made it very clear his health could take a sudden and dramatic turn for the worse if he didn't back off the Stingaree.

"From now on, we're traveling together," said Weymouth, who looked and dressed so much like Bellon they could pass for twins.

"Things can't be that bad," said Bellon.

Townsend interjected, "From what Keno briefed us on, we must be careful."

It took a few days for Bellon to adjust to his companions. He jokingly referred to the detectives as his "small army," but he also took the job seriously since "danger began to jell."

Just days into the assignment, Bellon would discover just how valuable his new partners were when an elderly pimp attacked him with a double-bladed axe. Weymouth tackled the old man before he could hurt anyone.

To strike at the heart of the Stingaree problem, the men served eviction notices to three brothels on waterfront row. Joseph Curby, a middle-aged barrel-chested man who "guarded his feminine business with a strong arm," owned the vice dens and was the backbone of vice along the shoreline. By best estimates, Curby cleared at least $50,000 ($1.25 million in today's dollars) a year, tax free.

Curby spied the trio approaching his business. Recognizing Bellon, he confronted the men on the sidewalk and was not happy. Pulling a .45-caliber horse pistol from his coat and aiming it directly at Bellon's head, the stocky pimp snarled, "Any closer and I shoot!"

Caught off guard, the policemen wisely backed down. Bellon later reported, "The pistol was a language we all knew. The man was mad, steaming. So we said adios and backed away."

Bellon had survived his early days in the Stingaree because he knew how far to push a person. That all changed when he was partnered with the cops, who advocated blunter tactics.

"Let's go back right now," Weymouth urged. "And throw the old boy in the jug. He pointed a loaded firearm at police officers."

"But what if Curby's trigger-finger becomes too happy?" Bellon nervously replied.

"Then we shoot it out!" Weymouth assertively declared.

Apparently the most cerebral of the group, Bellon had other ideas: "We're six hundred pounds of sinew, bone and lard. Curby couldn't miss such a big target. Let's think on it."

The men agreed to pull back. With time on their side, they could use less direct tactics.

For the next thirty days, Bellon, Weymouth and Townsend paid Curby a social call every afternoon. While Curby held them at gunpoint, they nervously spoke about having no control over the state law demanding they tear down the buildings. Bellon even offered to move all three houses to any other lot Curby owned in San Diego, free of charge. "We have no intention of destroying your lucrative business," Bellon duplicitously declared. "We're just doing our job."

The daily visits took a toll. Within days, Curby's prostitutes began to migrate elsewhere. So did his customers. By week's end, he was alone. In his memoirs, Bellon recalled, "When we arrived on the 13th day he [Curby] was beaten."

For a year, Bellon, Townsend and Weymouth were a force to be reckoned with, and brothel after brothel closed. Then tragedy struck.

The October 5, 1913 *San Diego Union* lampooned Keno Wilson's efforts to clean up San Diego.

WEDNESDAY, MARCH 15, 1916: Bellon, Townsend and Weymouth met at the waterfront for a midnight raid. Two and a half hours later, their work was done, and each man got into his own Model T to drive home. Bellon and Townsend made it safely; however, Weymouth was ambushed at the corner at Eighth Avenue and K Street when an armed man crept from the shadows, screamed angry gibberish and then shot Weymouth in the abdomen.

By the time the police ambulance delivered Weymouth to the Agnew Sanitarium at Fifth Avenue and Beech Street, doctors and the next day's newspapers gave him no chance to live.

Weymouth spent several months in critical condition; the bullet tore sixteen holes through his intestines. Despite the grim forecast, he eventually recovered and moved away.

With so many people wanting Bellon dead, detectives questioned whether Weymouth was even the right target. Not only did he and Bellon look alike, but they also wore the same bulky suits, vests and dark-brown hats.

By 1917, the Stingaree was closed forever. Reginald Townsend was reassigned to investigate murders, but by then, the world had changed. Chief Keno Wilson had been fired, and the female and minority officers he'd hired during his progressive tenure were being forced out. The Great War (World War I) slowed down the firings, but Townsend was ultimately let go in 1919.

# LOS FUGITIVOS

**W**ednesday, January 10, 1918, 10:00 a.m.: On the Encanto Road just east of Mount Hope Cemetery.

"My God, there is a body here!" John Shelton exclaimed to his coworkers. A lineman for Consolidated Gas & Electric Company of San Diego, Shelton had just climbed the cross-arm of a telephone pole the company was installing when he looked down into the thick brush and spied the body of one of San Diego's most respected citizens, forty-three-year-old Frank M. McCrary. A local jitney driver and dedicated family man, McCrary had been shot behind the right ear at close range.

Shelton ordered his crew to guard the body. Jumping behind the wheel of the company truck, he set out on what would become a half-mile trip to locate a home that had a telephone. With the receiver planted in one ear, Shelton frantically turned the crank on the side of the phone. As soon as the operator came on the line, he barked, "Connect me to the police!"

The operator connected the call to FRanklin1101, the main line into SDPD headquarters. After reporting the body to the desk sergeant who answered the phone, Shelton was quickly connected to Detective Harry J. Kelly. Kelly copied down the information and then relayed the killing to his boss, Detective Sergeant Paul Hayes.

Within minutes, Hayes and Kelly had connected the Shelton call to a missing person report. Earlier that morning, Marion McCrary called to report his normally reliable father had not returned home from work the previous night.

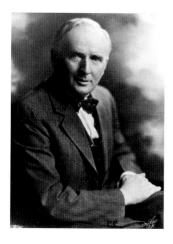

Chief of Police Stewart P. McMullen served at one of the most challenging times for the SDPD.

Hayes reported the killing to his superior, Detective Lieutenant James Patrick. Together, the men walked down the narrow hallway to brief the chief of police, Stewart P. McMullen, on the latest bout of carnage.

San Diego had changed a lot in just a few short years. What was a sleepy village of seventy-eight square miles and 40,000 residents in 1910 had, due to World War I, swollen to a population exceeding 95,000, with the largest concentration of military bases in America. At Camp Kearny, the home of the famous Fortieth Division, there were upward of 60,000 soldiers. At the U.S. Naval Training Center in Balboa Park, thousands of blue jackets were being schooled in how to serve onboard seagoing warships. Combined with the other military-related locations—Rockwell Field, Fort Rosecrans and the warships in the bay—the military population easily exceeded more than 100,000 young men.

Inevitably, with the servicemen came parasites who lived off them: bootleggers, loan sharks, gamblers and a host of shady ladies willing to trade flesh for cash.

So many changes in such a short time pushed the relatively small force of SDPD officers to the brink. Unsolved murders began to stack in the Detective Bureau. A jitney driver was robbed and then beaten to death. An army paymaster was brutally slain. The badly mangled body of an unknown man was found behind a lonely warehouse along the waterfront. Civilians and servicemen alike reported being robbed while out on evening strolls.

Given his community standing, McCrary would have been the last person to ever get involved with unsavory sorts. Whoever killed him was motivated by evil or robbery versus revenge.

While the dead man was a priority for the SDPD, its top cop had larger issues. In office for a little more than a year, and a political wonk with no prior police experience, Chief McMullen was under intense public pressure to rein in the epidemic of larceny and violence gripping the city.

The chief was also at the center of a very public controversy after Detective Fred Doty of the Purity Squad mistakenly arrested two young women at the YWCA. In attempting to quell the ensuing civic outrage, the chief incurred

an internal blowback after telling the *San Diego Union*, "If members of this police force cannot use brain work, we will get a new police force."

Now this.

Chief McMullen assigned Captain Joe Myers to personally handle the case. Detective Inspector Paul Hayes would serve as case coordinator.

The chief and Myers were at the crime scene within the hour. Detective Kelly and Lieutenant Patrick were already there. Patrick briefed his superiors on what they had learned. The victim owned a Dodge Brothers touring machine (automobile) that was missing.

Myers noted a fresh set of tire tracks alongside the road indicated a machine had pulled over. Drag marks from the tracks to where the body was found indicated the murder occurred elsewhere. A fresh set of footprints, consistent with the drag marks, was found; however, they were of an average size and lacked any distinctive identifying information.

Absent someone turning themselves in or a stool pigeon dropping dime on the killer(s), Myers knew that they'd need to locate the machine with the gunmen behind the wheel if there was any hope of cracking the case.

Myers scribbled the case information for an all-points bulletin (APB) to be put out over the statewide teletype system. Handing the paper to a uniformed patrolman, Myers said, "Get this to headquarters."

The captain then needed to make a calculated gamble. Experience dictated that if the machine returned to the urban core of San Diego, it would be found. There was no way it could go too far west due to the Pacific Ocean. Given the population density to the north, the machine would be spotted trying to get to Los Angeles. To the south was Mexico. The APB would alert local border inspectors in case it tried to cross into Mexico. The best avenue of escape would be east, where someone could hide in the mountains or continue along the barren desert road to Arizona or even south into Mexico.

Myers ordered Kelly and Patrick to head east.

Myers then helped the coroner load up the body. As he watched the ambulance head toward downtown, Myers looked at his boss. "I want to follow Kelly and Patrick, but I need to use your machine. Can you get a ride back with one of the flatfoots, or did you want to come with me?"

The chief answered by jumping behind the wheel of the Cadillac and exclaimed, "Come on, Joe!"

The pair caught up to Kelly and Patrick in the small town of Dulzura. They were sixty miles from downtown.

"There are two soldiers in the Dodge, and they came this way!" Kelly anxiously reported. "We met the army paymaster and his guard coming in

A 1914 Model T serves as the centerpiece of the San Diego Automotive Museums exhibit of the ninety-mile plank road between El Centro and San Diego.

from the Imperial Valley. He informed us they passed through Campo at three thirty o'clock this morning."

Chief McMullen ordered Myers and Kelly to continue the chase. He and Patrick would head back to headquarters.

"Keep after them, Joe," the chief ordered. "Draw on any bank if you need money. I will see to it that things are taken care of. Now go get those men!"

One hour later, Kelly and Myers were questioning the owner of a small, family-owned filling station in Campo. The soldiers had awakened them at two o'clock that morning to purchase twelve gallons of gasoline and two quarts of motor oil.

"Did they say where they were going?" Myers asked.

"Yes. They said they were traveling to San Diego, but when they left here, it was all wrong."

"What do you mean?"

"They went east."

"Describe them," Kelly requested.

"Just a couple of fellas," the station owner answered. "I think I'd know them if I saw 'em again."

Kelly looked directly at the station owner's wife. "Did you happen to notice anything in particular about them?"

"Well now that you mention it, yes," she replied. "One of them had the deepest voice I had ever heard. I remarked about it at the time."

The interview concluded shortly thereafter.

Without the convenience of Interstate 8, a modern superhighway that traverses the desert of eastern San Diego County, the detectives turned their machine back onto the rutted twenty-five-foot-wide wood plank road and slowly continued east toward Arizona, one bone-jarring mile at a time. With only a description of two soldiers, one with a deep voice, they needed a lot more.

As Myers drove, he said to his partner, "With thousands of soldiers around here, there's a chance we are on a wild goose chase, but it's all we got."

The pair soon happened upon a railroad construction crew. They learned the foreman had spotted the Dodge Brothers touring machine near El Centro a few hours earlier.

"What was the machine doing when you noticed it?" Kelly asked.

The foreman removed his cap and wiped sweat from his brow. "It was parked alongside the road, and two soldiers were working on it. One was underneath. I pulled alongside and asked if they needed any help, but they didn't answer me."

Myers and Kelly continued to El Centro, a tiny desert town of five thousand residents. Hoping the notorious desert wind didn't shove sand dunes over the plank road, leaving them hopelessly lost, the men finally reached town more than ten hours after leaving San Diego. They immediately went to the office of Imperial County sheriff James Applestill. After they explained their case, the sheriff authorized his entire department of eight deputies to assist their San Diego counterparts.

As deputies organized for the search, Myers met with the sheriff.

"If the men you are chasing are the killers, they'll undoubtedly head for Mexico," the sheriff said.

"How can you be so sure?"

"Because they're in uniform. They'd be arrested at the Arizona border as deserters," the sheriff answered.

The sheriff reached for his phone. After requesting the operator to connect him to Calexico, the sheriff said to Myers, "I'm going to have officers cover the border."

THURSDAY, JANUARY 11, 1918, 7:00 a.m.: Myers phoned SDPD headquarters and spoke with Paul Hayes. He learned that as he and Kelly had traveled east, Detective Joe Lopez had traced McCrary's movements in the twenty-four hours leading up to his murder.

In speaking to a friend of the slain man, Lopez learned McCrary had been spotted at the cab stand at Fifth and Broadway at 10:30 p.m. with two soldiers in his machine. Louis Carswell, another jitney operator who routinely shared the stand with McCrary, told Lopez he, too, had seen the soldiers in the machine.

"Did he find anything else?" Myers asked.

"He sure did," Hayes declared. "According to another jitney driver named Edward Register, two soldiers with light blue infantry cap cords approached him earlier that night asking for a ride to Lemon Grove. This guy Register said as he drove them, the soldiers were asking a lot of questions, which made him nervous. According to Register, he said he really got spooked when the soldiers insisted he change his route to National City and to take a dark, lonely road. Register said he was so scared he feigned motor trouble so the guys would leave his car."

"And did they?" Myers asked.

"Yes. Apparently they bought the mechanical excuses and said they'd jump a streetcar from there."

"Can he ID them?" Myers asked.

"He claims he can," Hayes answered. "He gave a pretty good make on them already, including saying one of them had an incredibly deep voice."

Myers was now more convinced than ever that he and Kelly were on the right path.

Hayes continued. "Joe also located a guy named R.H. Metz. He said he'd been standing with McCrary when two soldiers came up and asked about a ride. When McCrary said it would be about an hour and a half to get out there, the two jumped in his machine and they left. This was around 10:30 p.m."

Myers was furiously writing in his leather-bound notebook. "Anything else?"

"Metz claims he can ID both soldiers. He also added one of them had an incredibly deep voice."

Myers pumped his fist.

Hayes continued: "Joe also spoke to the widow of McCrary. Like we suspected, McCrary didn't have any enemies, and he wasn't in debt. The widow said her husband also didn't carry much money with him. In fact, the only thing he had that was even identifiable was a bright-colored lap robe with red and blue checks."

"Thanks, Paul," Myers said. "This was all very helpful."

Back in El Centro, the breaks were coming fast. As deputies used the morning sun to scour the border for the missing machine, a rancher happened to drop into the Calexico police station. Curious about the flurry of police activity, the rancher reported seeing a Dodge touring machine parked along a dirt road leading into Mexico.

"Inside I saw two soldiers," the rancher said. "I remarked to my ranch hand the men were either asleep or trying to hide because they were slouched down."

Minutes later, Myers and Kelly stood beside a broken-down automobile on a lonely dirt road three hundred yards north of the Mexican border. Kelly's report noted the front tire was blown and the machine had been driven some distance on the wooden-spoked rim. The machine had apparently been driven at high speed without motor oil, and the engine was seized.

As Kelly examined the outside of McCrary's machine, his partner searched inside. The only item of interest was a soiled pair of men's underpants with the initials "WBG" and an indistinguishable laundry mark. The lap robe was nowhere to be found.

Looking south to a haphazard barbed-wire fence that defined the border between Mexico and the United States, Myers told Kelly, "I guess we now know where they went."

The men regrouped with Sheriff Applestill back at the Imperial County station.

"I'm going to Mexico," Myers declared.

The sheriff grimaced. Mexico was in a state of turmoil and had no history of cooperation with American authorities. Just two years earlier, the United States Army, led by General "Black Jack" Pershing, had invaded Mexico in pursuit of Pancho Villa. An American policeman crossing the border did so at his own risk. Myers knew it would be suicidal to hunt two killers unarmed, but the penalty for carrying a firearm in Mexico was execution by firing squad.

Myers's stubborn insistence told the sheriff a compromise was needed.

"I will let you go into Mexico on one condition," the sheriff capitulated. "You have to take Deputy Henry Gonzalez with you. He grew up along the border, and he knows all the customs. He also speaks Spanish and knows most of the *policia* in the area. He's your best chance for survival."

Myers considered the offer.

"Do I have a choice?" he asked.

"Yes. You can go back to San Diego, or I can arrest you for trying to cross the border without permission."

Myers offered a conciliatory handshake.

One hour later, Kelly was ordered to return to San Diego, and Myers and Gonzalez walked the dirt road into Mexico.

FRIDAY, JANUARY 12, 1918: Kelly returned to SDPD headquarters with the soiled underpants and a report of Myers's decision to go into Mexico. Chief McMullen was less than pleased. Paul Hayes would later describe Myers's time in Mexico as one of the most anxiety-riddled periods of his life. Kelly was then ordered to appear in court to testify on a statutory rape arrest he made on C.C. Miller of 347 Forty-Seventh Street.

The ID Bureau soon deciphered the laundry mark on the underwear to read "B-18." Officers were sent to laundries across the city to try to connect the number to a suspect. Eventually, the number was traced to a man who could prove he wasn't related to the crime. It also helped his alibi that his initials were not "WBG."

Hayes drove to Camp Kearny and met with the commander of the military police for San Diego, Major King.

"I know it's a big job," Hayes pleaded. "But I need a list of deserters that vanished from your base two days prior to the murder."

Major King considered the request.

"You're looking for infantrymen, are you not?"

"Yes."

"That's a tall order, inspector, but let me get started. I'm warning, this will take some time."

Hayes gave a conciliatory smile.

The major proved to be faster than first intimated. He delivered a report to SDPD headquarters just hours after meeting with Hayes. Unfortunately, the list contained the names of hundreds of men.

As Hayes and Detective Henry Stevens pored over the report, they eventually keyed in on two deserters, Frank Churchill and Bernard

Ryan. Both men matched the description of the killers to a T. Further examination revealed both men had bad conduct records on the post, and one was wanted on a forgery beef in Northern California.

The leads looked promising. Stevens hurried back to Camp Kearny to collect the personal effects of the AWOL soldiers.

Back at headquarters Hayes ordered the ID Bureau to develop photos of the suspects for distribution. Telegrams were then dispatched to the hometowns of the wanted men requesting stakeouts on known associates, sweethearts and family members.

Three days later, the telegrams paid off. Churchill and Ryan were arrested by the Los Angeles County sheriff in Newhall. It turned out to be a dead end. Despite Ryan having a severe cold that left him with a deep voice, both men proved they had nothing to do with the slaying.

By now, Kelly and Stevens had whittled down the massive list of deserters to four Colorado draftees assigned to Companies B, D and E of the 157th U.S. Infantry. Hayes ordered Stevens and Kelly to get photographs of the men and have them enlarged by the ID Bureau. He'd already arranged for Register and Metz to come by headquarters and look at the photos.

LATE FEBRUARY 1918: THE SDPD had only heard from Myers twice since he entered Mexico. His first message informed them the names being used by the fugitives were Bob Hayes and Jack Miller. The second message was a third-party telegram via U.S. Customs requesting the SDPD post a bounty for the killers. Myers ended the message with, "It will make a difference down here."

Hayes would later learn that what happened to his captain in Mexico could have filled a book.

First, there was the issue of trying to enlist the cooperation of the Mexican police. It was only because Gonzalez came along that the *policia* even offered a modest attempt at assistance.

Then, the machine Myers and Gonzalez rented broke down due to the horrid road conditions. The men eventually bartered two old horses but still couldn't get reinforcements to back them up in searching a rancho the fugitive killers were rumored to be hiding in.

The lawmen eventually returned to the border town of Mexicali, frustrated and dirty. Later, while cooling off in a saloon, Myers overhead a conversation about two gringos who had been working on an irrigation project one hundred miles south. After rounding up a small posse of Mexican lawmen, Myers and Gonzalez set out on a long, dirty horseback ride south.

After days of riding under an unforgiving sun and cold nights of sleeping under the stars, the posse arrived to discover the gringos had left just a half hour before. Several witnesses stated the men were carrying a red and blue lap robe.

Myers wanted to continue the chase, but the posse had other ideas. Short of any authority, Myers and Gonzalez were forced to turn around.

Then they got lucky. As the posse was preparing to leave, the job foreman said the gringos had mentioned going to Paragones, a Mexican town just south of the U.S. border. With a known destination, Gonzalez implored his Mexican counterparts to deliver them to Paragones. It turned out to be a wild adventure. After riding through almost impossible terrain and fighting off wild animals, the posse arrived in Paragones in plenty of time to intercept the fugitives. After sealing off the only two roads leading into town, they lay in wait the entire night. The fugitives didn't show.

The next morning, Myers tried to telephone the project foreman but discovered the lines had been cut. Finally, after many hours, he managed to get an operator to connect them, only to learn the pair had returned an hour after the posse left for Paragones. Myers was even more disappointed to learn the crew told the men a *gordo* (fat) policia and a *poquito* (small) Mexican had been there looking for them.

Myers and Gonzalez were heartbroken. They arrived back in Mexicali exhausted and almost ready to quit. Almost!

The following morning, Myers sent his card to Governor Estevan Cantu, the military commander of Baja California, requesting an audience. He got it. After a short bout of pleading his case, Myers was rewarded with a cadre of armed men for backup. He'd soon discover his troubles were far from over.

Myers and Gonzalez traveled the border from garrison to garrison, only to discover a common theme. Despite the approval from Governor Cantu, no one would move until their horses were fed. That sent Myers back to Calexico, where he purchased feed for the animals.

With the regiment now in action, they soon learned that the fugitives had been less than a mile away when Myers went to Calexico to get horse feed.

WEDNESDAY, MARCH 13, 1918: Myers eventually located a phone to call into SDPD headquarters. Ready to narrate his progress report, he was interrupted with some welcome news.

"Come home, Joe," Paul Hayes said. "We've identified the killers."

Through the tireless work of Detectives Stevens and Lopez, the bureau identified William B. Grissom and Horace St. John Clark as the triggers in the McCrary slaying. Stationed at Camp Kearny, Stevens had already retrieved the service records of both men, as well as clothing and pieces of soiled cardboard.

Army records showed William Grissom enlisted in Denver and Clark in Park Dale. Grissom listed no family. Clark referenced a father in a small Texas border town.

Myers bid farewell to Gonzalez and Sheriff Applestill and set out across the wood plank highway back to San Diego.

Paul Hayes would later reflect that at first the Camp Kearny evidence seemed of little value. Then, as he examined the cardboard closer, he noticed faint pencil writing that read, "Gladys Galbraith, 1900 Stout, Park Hill Car 40."

The clues rang familiar. In 1903, Hayes had lived in Denver. He could remember a Stout Street and a streetcar line known as "Park Hill 40." Hayes quickly rang for the department stenographer to dictate a letter to the chief of the Denver Police Department. Along with the letter went a flier requesting information on Grissom and Clark.

SUNDAY, MARCH 17, 1918: Myers returned to SDPD headquarters with a full beard and a much slimmer waistline. Still unwilling to quit, Myers and Kelly made three more trips south of the border to find Grissom and Clark. Each time, they came up empty.

Denver detectives located Gladys Galbraith; however, she offered little information. Claiming to be happily married, she admitted she knew Bill Grissom but insisted she wanted nothing to do with him. She almost had Detective Sergeant Jeremiah Berry convinced until she ended the interview by saying, "And even if I did know where he was, I wouldn't tell you."

Berry immediately ordered Gladys to be followed as she left the police station.

The next morning, a very angry Mr. Galbraith was at Denver PD headquarters demanding to know why his wife was being tailed. When Berry explained the hunt for the two killers, Mr. Galbraith changed his demeanor. He even told Berry, "Even though Gladys claims she wants nothing to do with Bill, she still keeps his photograph."

Sensing an opportunity, Berry told Mr. Galbraith, "If you help me find Grissom, I will help you with your marriage."

TUESDAY, APRIL 9, 1918: Mr. Galbraith delivered Berry a letter addressed to Gladys: "Dearest, for God's sake please don't tell anyone I am in Denver. Be sure and burn this as my life won't be worth a dime if I am caught. You're the only woman in the world I would trust with my life."

The letter went on to state Grissom and Clark were working as ranch hands in the town of Fountain, Colorado. They requested Gladys meet them on April 10. Grissom promised to rob the boss of the payroll, and the trio could flee to Mexico with enough money to live on forever.

WEDNESDAY, APRIL 10, 1918: Three Denver policemen arrived at the John Smith Ranch and arrested Grissom and Clark without incident.

Back at Denver PD headquarters, Clark, who was just three days shy of his eighteenth birthday, quickly folded and confessed to killing McCrary and dumping his body. He also fingered Grissom as the mastermind of the entire thing.

Saturday, April 13, 1918: Myers and Detective Reginald Townsend arrived in Denver to take Grissom and Clark back to San Diego.

Thursday, May 16, 1918: The disgraced soldiers stood before a general court-martial board at Camp Kearny. Grissom was charged with murder, auto theft and desertion. Clark, because of his age and his eager confession, was only charged with auto theft and desertion. Both men were convicted. Grissom was condemned to hang, while Clark was given thirty years of hard labor at Leavenworth Federal Prison.

President Woodrow Wilson eventually commuted Grissom's death sentence to life at McNeil Island Federal Prison in Washington State.

The unwavering determination and fearless nature of Joseph Myers led to the capture of two very elusive killers.

# DEATH IN ROOM NINE

**W**ednesday, May 15, 1918, 12:00 a.m.: Patrolman O.U. Martin used his department-issued brass key to unlock the police callbox on his beat. Grabbing the hard metal phone inside, he was connected to the desk sergeant at police headquarters within a minute.

"There's been a murder," the policeman said. "I need detectives to meet me at the Prescott Hotel at 542 Sixth Avenue."

Newly promoted Chief of Detectives Joe Myers arrived shortly after midnight. He met Martin in the ground-floor lobby of the modest four-story hotel.

"Her name's Clara Miner," Marin reported. "She's the housekeeper here at the hotel."

"Where is she?" Myers asked.

Martin gave a head nod. "Follow me."

The policemen trudged up a narrow flight of stairs to the second floor.

"In here," Martin said as he motioned to room nine.

Not knowing who the killer was or where he or she could be hiding, Myers drew his handgun and then cautiously pushed open the door. His eyes locked on a girl sprawled on the floor, her arms flung wide in an awkward gesture. Her right arm bore a number of bruises near the elbow. On her forehead was a deep gash, peculiar in appearance, from which she bled profusely. Her sightless eyes stared vacantly toward the ceiling. Dressed in a thin undervest, a black skirt, shoes and stockings, it appeared she'd been attacked as she prepared for bed.

The tall chief with the walrus mustache walked over to the body and felt her skin. She was still warm.

"Find the hotel proprietor," Myers said to Martin. "I want to see if they know anything."

Minutes later, Myers was interviewing Mrs. Anna Johnson.

"Did you find the body?"

"No sir," Johnson answered. "Two sailors did. They entered room nine by mistake. When they found her, they called me."

Officer Martin quickly spoke up. "The two sailors are still here, Chief. I've held everyone who was in the house at the time."

Myers nodded approvingly and then continued questioning Johnson.

"What happened after you found the body?"

"I saw that she was terribly hurt—that she was bleeding, so I tried to wash her face. Then I called the ambulance and the police."

"Did you come to this room here?"

"Yes, I did," Johnson replied. "The door was unlocked, just as you found it, and the light was on. I looked around and found her nightgown on the bed there."

"How long has she been employed here?" Myers asked.

"Several months, I should say."

"Has she ever been married?"

"Yes, she has, but I believe she and her husband are separated."

"Did she ever speak of anyone who would do her harm?"

Johnson shook her head no.

"Clara had gone to a show earlier, and when she returned she had company: a girl and her sweetheart. At about ten o'clock, the company left. That's when Clara and I went into the kitchen and ate. Then I remarked that I had a headache and was going to bed. Clara said she was tired too. We talked for a few minutes more, then Clara started for her room. I turned out all the lights except for the one by the fire escape and went into my place, room twelve, and locked the door."

"Did you hear anything unusual after you went to bed?" Myers asked.

"I heard only one thing," Johnson said. "Someone—I feel a man by the way he walked—came into the hotel and walked down the hallway to the rear of the building. I must have gone to sleep because I heard nothing further until the sailor boys woke me up at midnight."

"Can you give us an idea what time it was when you went to sleep?" Myers asked.

"Yes, I can. It was just a few minutes past eleven o'clock. I know that because I snapped out the light and it read five minutes to the hour. I go to sleep very quickly, and I was tired last night."

"That sets our time very definitely between 11:05 p.m. and midnight," Myers remarked as he and Martin joined Patrolmen Setser and Campbell. The two new policemen had the hotel guests corralled in the hallway for Myers to interview.

The chief began with the sailors.

The bluejackets, both stationed on the USS *Vicksburg* but renting room eight, offered little beyond what the police already knew. They'd gone to a show earlier that night. When they returned to the hotel, they accidentally staggered into room nine, where they found the dead girl.

The remaining hotel guests were also questioned but offered nothing of substance.

The next step was to check the hotel registry. Standing behind the large lobby desk, Myers methodically thumbed through the handwritten journal.

"Did you rent any other rooms last night?" Myers asked.

"Now that I think of it, I did," Johnson answered. "At about ten thirty, just after Clara went to her room, a soldier came in, and I rented him room seven…"

Myers looked down at the book and pointed to a handwritten entry that read "Jack Cree."

"Is this the soldier?"

"Yes, that's him."

Myers noted there was no address associated with Cree following the entry of his name. The chief motioned to the uniformed patrolmen to join him behind the hotel desk.

"Have any of you located someone named Jack Cree?"

"No, sir," Campbell answered. "But we did check room seven, and the bed hasn't been slept in."

The policemen had done as much as they could at the scene. The real investigation would start back at the bureau office.

8:00 A.M.: THE FIRST order of business for Myers was to assign Detective Henry Stevens to the case. After his ordeal in Mexico, Myers would return to the more traditional administrative role demanded of a chief of detectives. It would be up to Stevens to conduct the needed legwork to crack the case.

Hoping to locate the mysterious Jack Cree, Stevens began his morning by returning to the scene of the crime. A one-on-one with the landlady of the Hotel Prescott could lead to additional information. He found she had regained her composure.

"When did you last see this man Cree?" Stevens asked.

"After I showed him to the room, I went back to the parlor. I was just closing the door when I saw him going down the staircase to the street."

"Can you describe him?"

"That's a hard thing to do. I only saw him a few moments. He was about thirty-three years old, about five feet seven inches tall and was dark complected."

"Did you have much to say to him?"

Mrs. Johnson hesitated. With a resigned look, she offered, "I may as well tell you all that happened. When I took him to his room, he began to act terribly. I told him

Detective Henry C. Stevens.

he couldn't carry on that way in my hotel and to behave. He quieted down somewhat, and I left him. Then, as I watched him go down the stairs, he called me a terrible name. Although I cannot describe him, I feel sure if I were to ever lay eyes on him again, I couldn't fail to recognize him."

Stevens noted the new leads.

"Did Clara ever have any trouble with anyone?"

"Why, yes. Several weeks ago, four soldiers from Camp Kearny had rooms here. One of them accused Clara of stealing forty dollars from his room while she was cleaning it up."

"What happened?" Stevens prompted.

"The military police were called. One of your officers was summoned as well. They told me afterward that the soldier lied."

"Thank you. That will be all," Stevens said politely.

The next several hours were spent going room to room in the hotel, searching for anything that might help Stevens crack the case. He came up empty-handed. His bureau report reflected that room nine was modest, with the furniture neatly arranged. A light coating of dust on the highly polished wood furniture was undisturbed. There were no fingerprints found.

There were only two exits from the hotel: the front entrance onto Sixth Avenue and the fire escape located at the rear of the building. Stevens noted the door leading to the escape was hooked from the inside. Whoever killed Clara was either still inside the hotel posing as an innocent party or had walked out the front door.

Stevens walked out onto the sidewalk and looked in both directions. He needed a break. Figuring other nearby hotels were as good a place to start as any, Stevens first met with the landlord of the Aspen Hotel at 561 Fifth Avenue.

"Did you have anyone come in here early this morning looking for a room?" Stevens asked the landlord.

The landlord looked across the hotel lobby desk and then nervously asked, "Is this in regard to what happened over at the Prescott?"

"Yes," Stevens replied.

"I had a fellow, he was pretty drunk, come in at about five o'clock this morning. He was very nervous and wanted a room. I told him the price of a room was a dollar. He forked it over without saying a word, but he wouldn't sign the register."

Stevens's interest was piqued. "Go on. What about this fellow?"

"Well, this guy had blood on his hands and fresh scratches on several fingers. They looked like fingernail marks to me. Anyhow, he went to bed, leaving a call for eight o'clock. When I knocked on his door, he swung it open and then just glared at me like a wild man. Then he slammed it in my face."

Stevens began to look around the lobby for the nearest phone. If the man was still in the hotel, having a few more officers to help question him could make a difference. He noted the hotel didn't have a phone.

"Where's he now?" Stevens asked.

"He left about twenty minutes ago. And he sure was excited."

"Describe him!" Stevens commanded.

"About thirty-five years old. Five feet ten inches, and about 170 pounds. His hair was black with some gray around the temples, and he wore a dark suit with a fedora. He looked like a gambler, if you ask me."

Headquarters was three blocks from the Aspen. Stevens sprinted all the way back.

As uniformed patrolmen were ordered to search the city for the wild man with the scratched hands, Stevens was in the ID Bureau looking through folders of reports to identify the soldiers who reported Clara as a thief. He ultimately identified them. Via information confirmed in the presence of their superior officers, all had solid alibis on the night Clara was killed. This eliminated the men as potential suspects; however, Stevens gained some valuable information: Clara had a sweetheart, a sailor named Edgar Bowlus, and they were engaged to be married. Stevens soon tracked down Bowlus, but according to the swab, he, too, had an alibi.

Then Stevens began talking to some of the shipmates. Most knew nothing, but one exceptionally nervous sailor soon caught his attention. Holding out a cigarette to the young man, Stevens asked, "How well do you know Bowlus?"

"We run around a lot, so I guess I know him about as well as anyone."

"How did they get along? Was there ever any trouble?"

"Well, they did have trouble. It was over another woman. Bowlus was engaged to Clara all right, but he fell for another girl. This caused a lot of fuss."

"What's the name of this other girl?" Stevens asked.

"Mary Bedford. And she was very jealous and told Bowlus to stay away from her. I guess he liked Clara a lot because he still went out with her once in a while. When Mary got wind of that, she tried to kill herself by taking chloroform."

"Then what happened?" Stevens prompted.

Stevens noted the sailor's hands began to shake.

"I don't know if I ought to tell this or not," the swab declared, "but Mary told Bowlus that if he didn't leave Clara alone, she'd make a good job of it next time—that she'd kill both him and Clara."

"Any idea where this woman is now?"

"Yes," the sailor replied before providing Stevens an address near the Hotel Prescott.

Despite Bowlus's insistence that he was on base at the time of the murder, Stevens knew someone could slip off post after Taps. So he wasn't ready to exclude Bowlus as a suspect.

Meanwhile, patrolmen hauled in two possible suspects who matched the description of the man with the scratched hands. Neither confessed to anything, and neither could be fingered by the landlord of the Aspen.

Then came word the janitor of the Hotel Prescott hadn't shown up for work. Stevens quickly determined the man had previously been arrested for hawking liquor to uniformed service members and, by order of the police judge, had to leave town. It was well known by the hotel staff that the janitor spent money as fast as he made it. Was it possible he killed Clara for financial gain and then fled town? Backed by the fact there was no sign of a struggle, something that surely would have happened if a stranger suddenly appeared in Clara's room, Stevens added the janitor as one more possible suspect.

With the case becoming ever more complicated, Stevens asked his superior officer, Paul Hayes, for a partner.

"I only wish I could," Hayes responded. "I just put my last available man on the Klauber robbery case."

Melville Klauber, a prominent member of a well-established San Diego family and an eventual co-founder of the San Diego History Center, among other local institutions, was returning to his home on May 15 when he was accosted by two men in army uniforms. The soldiers slugged him, robbed him of his cash and an exquisite custom diamond-studded watch and then vanished.

While disheartened at the news, Stevens resumed his case, determined as ever.

He soon located Mary Bedford and questioned her.

Bedford admitted she was in love with Bowlus and that she knew Clara. However, she denied ever threatening to kill anyone other than herself. Regarding the suicide attempt, Mary stated it was financial issues and not a jilted heart that led to her desperate attempt. Mary closed out the interview by providing an alibi that Stevens easily verified.

Stevens's investigation soon eliminated Bowlus as well. That left the janitor and the mysterious Jack Cree as the only possible suspects.

Stevens spent the next several days questioning the commanding officers of various military installations around town about a service member named Jack Cree. No one knew of him.

Days turned into weeks. Weeks turned into months. The case had grown cold.

SATURDAY, FEBRUARY 1, 1919: Captain Frank M. McGraw of U.S. Army Intelligence arrested two soldiers, Chandos W. Howard and Allen C. Shaffer, for the robbery of Melville Klauber.

Detectives Harry Kelly and George Sears already had the men listed as their top suspects; however, Klauber couldn't make a positive ID. Without solid evidence, the dicks were left stymied.

The break came when the sweetheart of a soldier assigned to the Twenty-First Infantry took a gifted watch into a repair shop in a small town in Oklahoma. Recognizing the unique diamond-encrusted timepiece from a nationwide alert, the proprietor notified authorities.

Kelly and Sears drove to Camp Kearny and interviewed Howard and Shaffer. The pair quickly confessed to the Klauber job. Then, as he was being led to a cell, Howard offered up something else. What he had to say led Kelly and Sears racing back to police headquarters as fast as their machines would take them.

Stevens was summoned into the office of Chief Myers. Kelly and Sears were already there.

George M. Sears played a part in some of SDPD's most important cases of the early twentieth century.

"We think we know who knocked off the Miner girl!" Kelly excitedly proclaimed.

"Can your witness identify that fellow Cree if we can arrange a show-up?" Sears asked.

"Yes," Stevens answered. "I will go get her."

Thirty minutes later, a line of city jail inmates stood in the alley behind headquarters. Mrs. Johnson walked in front of each suspect, carefully eyeing each one. She hesitated twice before she finally placed her hand on the shoulder of Allen Shaffer.

"That's him!"

Shaffer jerked back. "How can you remember me after all this time?" he barked.

"Because you called me that horrible name."

The mysterious Jack Cree had been found!

Stevens and Sears spent the next several hours bracing Shaffer. He denied everything.

Stevens and Sears next took on Howard. The soldier also had an insolent posture until he realized the gravity of being charged as an accomplice after the fact. He quickly broke down and dimed Shaffer. Howard said Shaffer came back to Camp Kearny in the early morning of May 15, 1918, and confessed to killing "some dame downtown."

Stevens and Sears went back in for a second round of questioning of Shaffer. This time, the soldier cracked.

"So why did you do it?" Stevens asked.

The answer was shocking even to a policeman who thought he'd heard it all.

"I didn't mean to kill her," Shaffer sobbed. "But when she made some remarks about soldiers I didn't like, something came over me. I remember taking her by the throat and then falling on her. I must have cut her forehead with my teeth because I remember they hurt after I left."

On its face, the story sounded absurd. The detectives pressed on. They wanted a motive that could establish malice. They soon got it.

Shaffer eventually broke and confessed to lying in wait in the hallway. When he saw Clara opposite the door of room nine, he pounced on her and dragged her inside. Once inside, behind the privacy of a closed door, he used lace to strangle her.

When the DA entered a charge of first-degree murder, a bounce that would send him to the rope at San Quentin, Shaffer retracted his confession and entered a plea of not guilty. Without an independent witness or prints, the DA offered Shaffer the chance to plead to second degree.

MONDAY, MAY 5, 1919: Allen Chester Shaffer stood in court to receive his sentence. Shaffer was given ten years to life in San Quentin for murder.

Chandos Howard was only seventeen when he entered a guilty plea to first-degree robbery and was remanded to the state reformatory in Ione, California, until he became an adult.

# SECRETS IN CHINATOWN

**W**hile not as widely known as its San Francisco counterpart, the Chinatown District around Fourth and J Streets in the lower Gaslamp is steeped in tradition and history of a proud immigrant community established in the early 1870s. So assertive was SDPD in protecting this community that in 1917, Ah Quin was hired as one of California's first Chinese American police officers. When a prominent member of the Chinese community was murdered, SDPD devoted an extraordinary amount of resources toward bringing those responsible to justice.

WEDNESDAY, APRIL 7, 1920, 11:30 a.m.: It was a pleasant morning when Quon Choak went to visit the Chinese herb shop at 348 J Street. He arrived to find the business still closed. That was unusual. His friend and the proprietor, Tsoy Sai Wah, lived in the back of the storefront and usually opened his humble little shop every morning at 8:15 a.m. It wasn't like Wah, one of the most punctual people he knew, to be closed without advance notice.

Discovering the doors and windows to be locked, Choak began pounding on the door, calling out for Wah. There was no answer.

Fearing the worst, Choak barged into a neighboring business and called the police. He spoke to Chief James Patrick. Within thirty minutes, Corporal George Wilson was at the front door of the little business located in the heart of San Diego's Chinatown. Like Choak, his knocks went unanswered.

"Stand back," Wilson commanded as he raised his leg and used his heavy boot like a battering ram to kick open the door. Within two kicks, the entrance surrendered to reveal a violent massacre. Blood was splattered on the walls. A stream of fluid spilled from the victim's badly mangled head and deeply gashed throat to form a crimson pool in one corner of the room. The victim lay on his back. Near his outstretched hand rested a broken wooden table leg and a bloodstained meat cleaver. Several bloody footprints could be seen behind the store counter. Even the wall-mounted telephone hadn't escaped the violence. It had been violently ripped from its mountings and hung by its own wires.

The salt-and-pepper-haired corporal stepped across the small front room and used his department-issued electric flashlight to illuminate the back of the store. In one corner, he could see the safe; its door stood wide open!

Wilson turned to Choak. "Go to the phone and call headquarters," Wilson commanded. "Tell them there's been a robbery and murder and to send detectives."

Choak excitedly ran from the store to alert the police. Unfortunately, he also alerted almost everyone else in Chinatown. Within minutes, the little store was packed with curious onlookers as the single overwhelmed policeman tried to hold them back.

12:30 P.M.: DETECTIVE SERGEANTS Joe Lopez and Albert Carson, fingerprint expert Walter Macy and a number of additional uniformed patrolmen arrived to assist. As uniformed patrolmen pushed the onlookers across the street, Lopez escorted Choak into the backroom of the business to question him.

"When did you see Sai Wah last?" Lopez asked.

"I saw him yesterday afternoon," Choak answered. "At that time, I told him I would be around this morning to take him to see the doctor."

"He works for you, doesn't he?" Lopez asked.

"Yes. I own part of the business."

"Does he keep much money on hand?" Lopez asked as he motioned to the safe.

"That I cannot say," Choak answered. "He would normally have hundreds of dollars of the company money, but he also keeps money for those in our community who cannot do business with banks."

"I suppose it's common knowledge he has a lot of money here," Lopez responded.

"Oh yes, that's true enough. Is there anything in the safe?"

"Only bloody handprints," Lopez answered.

As Lopez questioned Choak, Detective Sergeant Carson located a woman next to the business who said she'd heard a loud noise followed by groaning emanating from the herb shop around 11:30 p.m. The woman said she thought nothing of the groans, as Wah was always sick, so she went to bed. The woman said she didn't see anyone suspicious, nor did she hear any more noises for the rest of the night.

As the detectives questioned witnesses, Macy searched the small shop for physical evidence. Gingerly sidestepping pools of coagulated blood, Macy was hunched over examining bloody handprints on the door when a well-dressed Chinese man stepped into the room.

"Who are you?" Macy demanded.

"Kwan Chee," the man answered as he pointed to the body on the floor. "He was like a father to me. You need to catch the man who killed him."

"We will certainly do our best," Macy declared. "When did you see Wah last?"

Hearing voices, Lopez joined Macy in the front of the shop.

"I saw him last night," Chee reported. "I want to put up a reward for the bad men who did this. How about $1,000?"

"We will get to that later, Mr. Chee," Lopez said. Turning to Macy, Lopez asked, "Did you find anything?"

"Yes. I found some excellent prints in blood on the door frame. I'm going to photograph them now."

"Can you do anything with them?" Lopez asked.

"Bring me a suspect, Joe, and I'll be able to tell you if that's your man. Whomever left these prints is obviously the killer."

Officers continued to arrive, including bureau men George Sears and Richard Chadwick. Dispatching more than two detectives to a murder was unusual for the era; however, Chief Patrick must have recognized the vulnerability of the community and wanted to get in front of the case.

Fred Boden, an inspector from the California Board of Pharmacy, soon joined them. This was also unusual for a murder; however, if there was anyone in the state who knew the Chinese community, it was Boden. For many years, he had helped regulate the trade of medicinal herbs and had gained the trust of the Chinese community, who mostly resided south of Market Street and west of Fifth Avenue.

Sears and Chadwick only stayed at the scene a short time; they had been detailed to escort the Prince of Wales, who was arriving in the city that afternoon. Before he left, Sears gave Lopez a tip.

"Joe, make a search of this entire block," Sears suggested as he waved his arm westward. "Check across the street as well. That's where the hop joints and drug dens are. If my guess is correct, it's going to be one of them that's your suspect."

"You think it was more than one?" Lopez asked.

"I'd guess two or more based on what I saw in there," Sears confidently answered.

Lopez, Carson and Wilson spent the rest of the afternoon scouring the maze of rooming houses along J Street. Some were as small as fifty square feet and were without water or electricity. Many tenants did not speak English. With Ah Quin having left the department a year earlier, the department was stymied without a reliable translator. For those who did speak English, all said they hadn't seen or heard anything.

THURSDAY, APRIL 8, 1920, 8:00 a.m.: The day began in the office of Chief James Patrick. He officially assigned Lopez, Carson, Chadwick and Sears to the case. Inspector Boden was also at the meeting and agreed to provide state resources to the investigation. It would have been a welcome move.

The men regrouped at the crime scene to compare notes from the day before. Chadwick led the briefing. "According to Choak, Sai Wah should have had at least $1,700 [$21,000 in 2017] in cash and gold in the safe," Chadwick reported. "Evidence suggested Wah was in bed when he got up to answer the door."

"It was someone he knew, too!" Boden interjected.

Chadwick recoiled in shock. "How can you be so sure?"

"Because no one would get up and open the door to a stranger at that hour of the night."

"So you are assuming he was killed when that woman claimed to have heard him moaning?" Lopez asked.

"Of course. Either then or later."

"Not much later," Chadwick interjected. "The coroner said Wah was dead at least twelve hours when the body was found." The detective sergeant then pulled out an odd-looking instrument covered in dried blood. "This was found here yesterday," he said as he held the object up. It was approximately eighteen inches long, six inches in circumference and had the appearance of a heavy spring. On the end was an iron fitting, similar to a door hinge, with three holes drilled in it. There was evidence that a similar fitting had been broken off the other end of the device. "I think this is our murder weapon."

"They slugged him with that?" Boden asked as he took the device from Chadwick and handed it to Sears. "What do you think, George?" Boden asked.

Sears examined the object. It weighed approximately two pounds, and he agreed it could be the murder weapon.

"The Chinese use these things on the front doors of some of the older homes," Sears said. "Some of those doors are three inches thick, so they require a heavy spring."

"It doesn't belong here," Chadwick said as he examined the door. "My guess is they slugged him with that door spring and the broken table leg we found yesterday. When neither of those polished him off, they used the meat cleaver to chop up his throat. We have a job to do here, boys. We must find out where that door spring came from!"

Sears started for the door.

"That means a house-to-house search," he said. "If we can link that spring…" Sears was interrupted by someone twisting the locked doorknob to the store. Quietly, the detectives gathered behind Sears. With his backup in place, Sears quietly unlocked the door and threw it open. Two girls, one of Mexican descent and the other Caucasian, stood dumbfounded.

"Where's Sai Wah?" the Mexican girl asked as she tried to step into the store.

Sears blocked her with his body. "Hold on, sister. Who are you, and what do you want with Wah?" he demanded.

"Oh. I'm Elsa Rios, and this is Florence Matthews. Who are you?"

Sears stepped aside to allow the girl's in. "We're police officers. Why do you want to see Wah?"

Fear came across the girls' faces. "What's wrong? Where is Wah?" both nervously asked.

"What do you want with Wah?" Sears again demanded.

"I want to give him this," Elsa answered as she reached into her purse and pulled out a handwritten letter. The correspondence was addressed in English and was from someone with a Chinese name across the border in Tijuana, Mexico. The contents of the letter were written in Chinese.

The policemen offered seats to the two girls and explained what had happened to Wah. They appeared horrified at the news. They insisted they knew nothing about Wah; they were just there to deliver a letter.

"Are you sure you aren't here for something else?" Sears demanded.

"Honest, mister," Elsa replied. "That's all."

As Sears questioned the girls, Chadwick searched their purses. In Elsa's, he found a small bindle of opium. Both women were arrested for possession.

After booking the pair into the city jail, Sears, Chadwick and Lopez visited the mortuary to examine Wah. With the help of the coroner, they made a positive match of the door spring to the head wound Wah suffered.

Back to Chinatown. At 210 J Street, the trio of policemen contacted four men playing cards.

"Do any of you speak English?" Chadwick asked.

The youngest raised his hand.

Chadwick held up the spring. "Do you recognize this?"

"No savy that," the young man answered.

"What's your name?" Chadwick asked.

"Tom Lum."

"Do you work?" Sears asked.

Lum shrugged his shoulders and then grinned as he shook his head negatively. The other men—later identified as Who Law, Ching Quong and Henry Chung—all refused to answer questions. Like anyone else of that era who refused to answer a policeman's questions, the men were booked for vagrancy. As they were also gambling, the additional charge was added.

3:00 P.M.: THE THREE bureau men reconnected with Inspector Boden at police headquarters. After commandeering the department's Cadillac from the motor pool, they drove to 205 J Street, the home of Kwan Chee.

As they entered his small home, Chadwick noticed a spring similar to the one found at the business on a sofa.

"Where did you get that spring?" Chadwick asked.

"I've had it a long time," Chee grinned. "I've had it maybe two years."

"Where did you use it?"

Chee pointed to the door where the screw holes were visible. "I used it on the front door."

"You're a good friend of Wah, aren't you?" Lopez asked.

"Oh yes, I'm a very good friend."

"Who do you think killed him?"

"I don't know. Who do you think killed him?"

"Whoever it was used a spring just like the one you have in your home," Lopez fired back.

Chee looked directly at the policemen. "Killed him with a spring, huh? How do you know that?"

"Never mind that now," Sears insisted as he motioned for his partners to join him outside.

Once out of earshot, Sears said to his coworkers, "I don't like that bird. Yet we have nothing on him except he was a friend of Wah and Wah would probably only open his door to a friend at that time of night."

"One thing's for sure," Lopez interrupted. "Whoever did this had to have gotten Wah's blood all over them, their clothes and his shoes."

"Let's toss Chee's house and then take another look around this block," Chadwick declared. "Especially where we pinched those four card players. There has to be something, somewhere that we missed."

Other than a similar spring, the search of Chee's home turned up nothing. The search was expanded to the entire block of stores and small apartments housing first-generation Chinese immigrants. Still nothing.

After the fruitless indoor search, the bureau men turned their attention to a vacant, weed-strewn lot across the street. After an hour of searching through painful thistle weed, Chadwick discovered a pair of old tan oxford shoes. The shoes had been cut in a crisscross pattern, as though the wearer was battling painful corns, but the most interesting part was the shoes were literally covered in blood. Judging from where they were found, the pair could have been hurled into the lot from most of the apartments across the street.

"This is still a find, but we need to do better," Chadwick lamented as he showed the shoes to his partners.

FRIDAY, APRIL 9, 1920: The bureau men began their day by meeting with Quon Choak, who translated the letter Elsa Rios was carrying. It was a friendly note with no bearing on the murder. They also learned Choak had assisted Chief Patrick in interviewing the four men arrested for vagrancy. They all denied any knowledge of the murder. Before the four were released, they were fingerprinted, and the prints were checked against the bloody prints photographed at the crime scene. None matched.

A re-interview with Choak revealed the sixty-four-year-old murder victim was beloved within his community. Because he was a U.S. citizen and spoke English, many of the new immigrants had come to trust him with their personal affairs and their money. With a reputation such as that, the bureau men were shocked no one had stepped forward with information.

SATURDAY, APRIL 10, 1920, 8:00 a.m.: Sears, Chadwick and Boden were in the bureau office typing reports and examining evidence as Lopez recanvassed

Chinatown, hoping to turn up something that had been missed. The room was quiet when suddenly Sears exclaimed, "Hey guys, look at this," as he held up the bloody shoes.

Chadwick abandoned his typewriter to take a closer look. Boden was already standing over Sears's shoulder.

"What do you think of this?" Sears asked as he pointed to a heel of one of the shoes.

"That's odd," Chadwick declared as he examined the shoe closely. "The wear pattern looks as though the fellow who owned these walks on the side of his foot. Let's see the other shoe."

Despite being its mate, the other shoe did not have the unusual wear pattern.

"So what do you think about Kwan Chee? Could these be his shoes?" Sears asked.

Chadwick laughed out loud. "Are you kidding? Chee couldn't get his big toe into these."

"Well, nonetheless, I've found out a few things about Mr. Chee. It seems a lot of our patrolmen either know him or they know of him, and his reputation around town isn't all that good."

"How so?" Chadwick asked.

"That's the thing. No one can put a finger on him. He's just shady. Apparently, a couple of our flatfoots have seen him making several trips down at the waterfront since the murder. What do you suppose that was for?"

"I'm afraid I can't help with that one, George. But let's not forget, two men probably did this, so who does Chee play around with?"

"I knew that would come up," Sears replied. "And that's the thing; he doesn't seem to pal around with anyone. He's a loner."

"Is he married?"

"Yes, to a girl named Oh Fong," Boden said. "She's laid up in the county hospital right now taking the dope cure for opium."

"Dope cure!" Chadwick exclaimed. "There's an idea. Does anyone know if Chee is a hop head too?"

"I'm not sure," Boden answered. "Some Chinese see opium the same way you and I might look at drinking beer or whiskey. As long as it's done in moderation."

"How about this?" Chadwick offered. "Why don't we raid the opium dens tonight and see if we can pluck Chee out of one of them? If we arrest him for that, we can bring him down here on a dope charge and then see if he sings to killing Mr. Wah."

Sears nodded. "I can't say I have a better plan."

The men left the bureau office for some much-needed rest.

SUNDAY, APRIL 11, 1920, 2:00 a.m.: A squad of uniformed patrolmen and sergeants, along with plainclothes detective sergeants, investigators and inspectors of the Purity Squad, joined the paddy wagon chauffeur in the narrow alley on the east side of police headquarters. Chief Patrick conducted the briefing.

"We'll move fast and hit multiple places along J Street at the same time," the chief barked. "Hitting them at the same time will stop someone from tipping off the other places that we're coming. For each location, I want detectives to have at least one uniformed cop when you bust down the front door. I also want men covering the back of these places to stop anyone from running out the backdoor or jumping out the windows."

The chief's orders were clear. At 4:00 a.m., opium dens across Chinatown were raided. At half past four o'clock, Kwan Chee was arrested inside an opium den at 25 J Street and then hauled to police headquarters and booked into jail. Among the items in his possession was a large ring of keys.

Later that same morning, the coroner's inquest was held. While required by law, the hearing revealed nothing the SDPD didn't already know.

2:00 P.M.: AFTER A short nap, Sears, Chadwick, Lopez and Boden were back in the bureau office plotting their next move.

"These keys intrigue me," Chadwick mused. "Perhaps Chee has access to a bit more than we are aware. My thought is we go back to his apartment building and see if we can't find what the keys open."

An hour later, the men were back at the J Street apartment building, going door to door, trying locks. In a day before search warrants and extensive court rulings regarding search and seizure, the process-of-elimination tactic was a standard operating procedure in investigations.

One apartment at number 205 appeared to be unoccupied.

"We haven't searched this one," Sears declared. "I'm sure we'll probably come up empty, but I want to not leave any stones unturned here."

After trying several keys, the men finally found one that worked. Chadwick pushed open the door to reveal an unfurnished single-room apartment with dirty papers littering the floor. In one corner sat a barrel overflowing with used rags and old Chinese newspapers.

"What a dump!" Chadwick exclaimed as Lopez and Sears followed him inside.

"Well, this looks like a bust," Lopez declared as he leaned against a wall directly across from the door. Suddenly, he almost fell backward when the wall moved. His partners watched in amazement as Lopez regained his balance and then pushed back a secret wall that revealed a much larger room.

"My God, look at this!" Lopez yelped.

The secret room contained opium pipes, food and even beds for people to sleep in. As the men walked farther into the secret room, they could see another area containing furniture.

"Well now, who do you suppose runs this?" Chadwick asked sarcastically.

The men had searched the entire apartment and the connected secret rooms by the time Inspector Boden and Patrolman C.T. Johnson arrived.

"The jailor told me you'd all be over here," Boden said.

"Did you guys find anything?" the inspector asked.

"Nothing we can pin to a murder, if that's what you're asking," Lopez responded.

As he answered, Sears flipped over the rag-filled barrel the men had spied before becoming distracted with the discovery of the secret room. The first thing the men saw was another pair of bloody shoes.

As they celebrated the find, Chadwick glanced to the high ceiling. "There's something funny here," he said as he pointed upward toward connecters coming from the ceiling. "This joint seems to be equipped with both electric and gas lights. None of the other apartments seem to have that."

Inspector Boden added to the statement: "When it comes to gas and electricity, Chadwick is right; those connectors make no sense."

Using the barrel as a makeshift ladder, Chadwick stretched toward the ceiling and grabbed at the connectors. "These fittings are loose," he declared. "I can turn these screws by hand."

After opening a hole in the ceiling, Chadwick flopped his hand around inside the opening, hoping to feel something.

"There seems to be a small box up here," he said.

Suddenly, the box crashed to the floor, narrowly missing the detectives steadying the barrel. The impact with the floor sprung the box lid open. Inside was a roll of bloody U.S. Treasury notes held together with string. Next to the bills were small bars of solid gold!

"Get the chief over here, and have him bring Chee with him," Chadwick anxiously ordered.

As Chadwick waited, Sears and Lopez used odd and ends from the secret room to fashion a sturdier ladder. One by one, the slender men pulled themselves into the attic. There, they found additional gold and money. All totaled, there was more than $3,000.

5:00 P.M.: CHIEF PATRICK escorted Chee to the apartment for questioning. Chee adamantly denied everything, including ownership of the shoes. Despite the denial, the official report noted the shoes fit his feet.

Back at headquarters, Walter Macy delivered good news. Of the four men booked for vagrancy, one of them, Henry Chung, was wearing shoes with the exact same wear pattern as the first pair of bloody shoes. Additionally, the first pair of mystery shoes fit his feet.

Later that evening, Macy announced that after Chee was booked, he was fingerprinted. Once the prints were classified, the ID Bureau matched them to his real name: Song Dee. Macy then compared the inked prints he collected from Dee to the bloody prints collected at the crime scene. They were identical.

MONDAY, APRIL 12, 1920: The youngest man of the four arrested for vagrancy, Henry Duck Chung, finally cracked and rolled on Dee. With the assistance of an interpreter, Chief Patrick took the confession.

"Song Dee and I went to Sai Wah's place that night," Chung stated. "Dee knocked on the door, and Wah asked 'who is it.' Wah opened the door, and we went in. Dee asked him for a suitcase. When Mr. Wah returned, Dee asked him for his citizenship certificate. Sai Wah had to open the safe for this. He brought us the identification, and that's when Song Dee hit him with the spring. I used a hammer. Wah began to cry, but we kept hitting him, and it knocked him down. He cried some more, and I wanted to go. Song Dee grabbed the meat cleaver and hit Wah in the throat several times. He was quiet after that. I went into the room where the money was, and Song Dee and I filled our pockets with cash and gold. We left through the rear door."

"But you returned, didn't you?" Chief Patrick asked.

"Yes. We put the money in the place where you found it, and then we went back. We put the suitcase away and took the rest of the money. Song Dee put it in socks, and we put it in the attic."

"What did you do with the clothes you were wearing?"

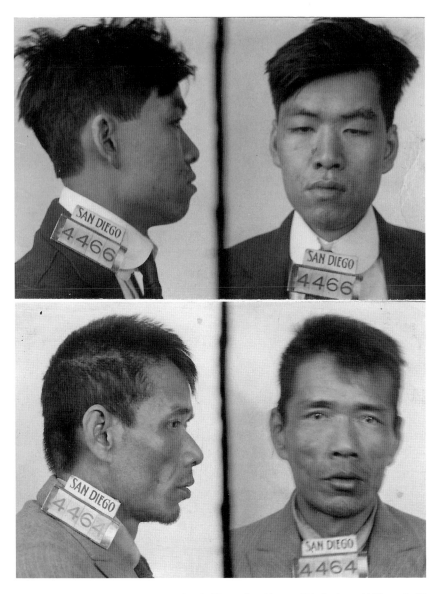

Song Dee (booking 4464) and Henry Duck Chung (booking 4466), the brutal killers of old Chinese merchant Sai Wah.

"We took them down to the waterfront and threw them in the bay. I threw my shoes away in a vacant lot behind where I was living. Song Dee tried to wash his, and I don't know what he did with them after that."

Chung went on to confess how he used his share of the money on narcotics.

Hoping to establish intent and malice aforethought—the difference between first- and second-degree murder—Chief Patrick asked, "Did you go to the herb shop intending to kill Mr. Wah?"

"No. The money was our intention."

"So you wanted to steal the money to buy drugs?

"No. I have people in China, and I had to send them money."

TUESDAY, APRIL 13, 1920: Despite his initial refusal to confess, a heart to heart with the jailer over what it would feel like to be hanged apparently changed Song Dee's mind about confessing. Both he and Chung accepted a plea of ninety-nine years in prison to avoid the rope at San Quentin.

# MURDER IN MISSION VALLEY

aturday, July 17, 1920: The crisp morning dawn had just appeared over a vast expanse of pristine Mission Valley farmland. Farmer Samuel Bailey was leading his small herd of cows to the shores of the San Diego River. Suddenly, one of his animals turned in revolt and ran in the opposite direction with its nostrils flaring. Aroused by the heifer's odd behavior, Bailey curiously walked closer to the riverbank. The fresh morning air was broken by the foul stench of decaying flesh.

Holding his nose to stifle his repugnance, the farmer pushed his way through the waist-high reeds and wild grass to see a pink shred of cloth peeking from the dirt. The farmer grabbed the cloth and yanked. It was too embedded in the ground for it to budge. Finally, common sense overcame the farmer's curiosity. This was a matter for the police.

Within an hour, Detective Sergeants Joe Lopez and Richard Chadwick were on the scene. Together, they pulled the cloth hard enough for it to dislodge, revealing it to be a Mackintosh waterproof-style raincoat. Underneath the coat, first popularized in 1824, was a large bundle wrapped in a blanket. With knives, the policemen carefully cut the blanket open to reveal the body of a woman in the advanced stages of decomposition.

The coroner was summoned. His notes summarized the female corpse was too decomposed to immediately determine a cause of death. Dressed in a pajama jacket, wrapped in two sheets and then wrapped again in a brown blankct, she was tossed into the crude shallow grave and then the

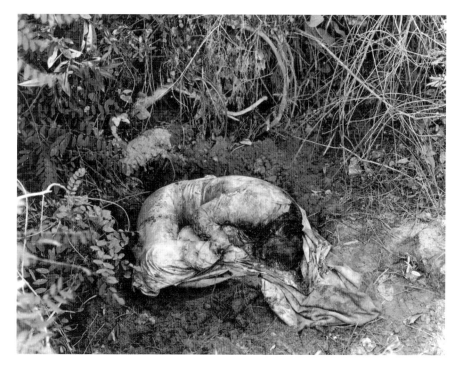

The body of Edna Mae Flash when police shoveled back the dirt and uncovered the grisly crime.

Mackintosh was tossed over her body. She was curled in the fetal position when the soil was shoveled over her.

The investigators quickly examined the clothing, hoping to find an identifying mark. To their frustration, each item had been deliberately cut to avoid identification.

"How long do you think she's been here?" Lopez asked Coroner Schuyler Kelly.

"Not sure," the doctor answered. "We may be able to get a better idea once we clean her up. Do you have any missing persons matching this description?"

The investigators looked at each other.

"None that we can recall offhand," Lopez finally answered. "When can you have that autopsy report?"

"Within the hour," Kelly replied.

As promised, the report was delivered to police headquarters within an hour. It revealed the deceased to be approximately five feet five inches tall

and 130 pounds, with brown hair. The coroner noted the body had no identifying marks or scars. From her condition, the coroner estimated she'd been dead approximately three to five weeks. The direct cause of death was not certain; however, there was nothing to indicate it was natural. The fact that she was found in a shallow grave also indicated murder.

The first task for the detectives was to identify the dead woman. There would be no way to crack the case otherwise.

As Sergeant Lopez brushed off the dirt and grime accumulated from the shallow grave, Sergeant Chadwick was in the ID Bureau combing through missing persons reports. One looked promising: a man had reported his wife missing three months earlier. Her description roughly matched that of the dead woman; however, so did thousands of others.

Chadwick drove to the home of the reporting party to get additional information. While there, he learned the woman was safe at the home of her parents and the family had simply forgotten to notify the police.

Chadwick returned to the office, where he met his partner. As he spread the garments across a large table, Sergeant Lopez said, "Look here. There's no question that the removal marks were deliberate; even the edges of the sheets have been cut away."

Carefully, the detectives examined the garments inch by inch. The blanket, coat and sheets were eventually cast aside. As Chadwick held the pajama coat up to the sunlight, he exclaimed, "Hey, Joe! Look at this!" Chadwick pointed to a faded mark on the collar of the garment. The men looked closely at the faded tag that read, "Hales Dry Goods."

As Chadwick noted the marks, he told his partner, "That's a Los Angeles firm. Do you suppose the woman was killed up north and dumped here?"

Lopez responded, "That would explain why we don't have a missing person report. At least it's something to go on. Is there anything else?"

Using his magnifying glass to study the item, Chadwick answered, "Yes. A laundry mark reading 2-0, and it's embroidered."

Further examination determined the mark to be old and badly faded. Repeated washings, particularly in harsh chemicals, had rendered it almost illegible. Thankfully, the mark was sewn in versus made with ink. If it had been the latter, a far more traditional method, there would have been no trace.

The detectives were jubilant. Finally, a starting place! Their feelings turned out to be short-lived. The 2-0 laundry mark turned out to be exceptionally common. It had been assigned to a man in a neighboring city, a marine stationed at the Balboa Park training center, a sailor on

a ship docked at the Broadway Pier, a soldier at Camp Kearny, a local hotel where all the laundry shared the same mark and a number of private residences throughout the city.

Even with such a daunting list, the sergeants were eventually able to track down a number of people and establish alibis, thus eliminating them as possible suspects. At a number of other locations, it was quickly determined there was no evidence a garment such as a pajama top would ever have been included in the laundry sent out. Those locations were eliminated from the list.

Together, the sergeants eliminated all but one possibility: the sailor attached to the ship docked in San Diego Bay. The sergeants soon learned he had left the city on leave on June 10, 1920, to visit his family in Portland, Oregon. He returned on June 24. Although the marine was given a glowing review by his commanding officer, Sergeant Lopez was leaving nothing to chance. He was still a suspect until something more solid could eliminate him.

A coroner's inquest was held. The official cause of death came as no shock: murder.

With the case officially designated a crime, Deputy District Attorney Oran N. Muir was assigned. His first order of business was to introduce himself to the investigators. After setting up an introductory meeting with Chief of Police James Patrick, Muir threw himself into his work. He later admitted this was his first murder case, and he became obsessed with it.

Shortly after the meeting between the chief and DA came a startling development. A man from Los Angeles identified the clothing and hair as that of his missing wife. Two days prior to the body being found, a telegram had arrived at SDPD headquarters reporting a woman missing. The husband described her as thirty-eight years old, with dark red hair, five feet five inches tall and 130 pounds. The telegram stated the wife had the habit of wearing a considerable amount of jewelry.

The husband was summoned to police headquarters for questioning. In the presence of Sergeant Lopez and Chief Patrick, the man broke down and cried when he examined the hair and underclothing of the dead woman. "That's my wife's hair," he sobbed. "And the underwear is exactly the same as she was in the habit of wearing. May I see the body?"

The request had to be denied. The body was in such a bad state that it was beyond recognition.

The husband was questioned about the garment she was wearing. He didn't recognize it and stated it was possible she had borrowed it.

Even without a visual identification, the husband was so sure the dead woman was his wife that Chief Patrick ordered Sergeant Chadwick to Los Angeles, and the remaining men in the Detective Bureau were tasked with tracing her every movement in San Diego.

Chadwick had the case turn on him in L.A. After locating the store that sold the pajama top, he learned it had been carried for years, and the top was so common it couldn't be traced to a particular buyer. In addition, the missing wife returned home safe and sound.

Chadwick returned home empty-handed. His partner was equally frustrated. Other than the laundry mark, which had proved to be a dead end, they were no further in solving the case than the day they took it. The men ended the week frustrated and exhausted.

SUNDAY, JULY 18, 1920: Determined to enjoy a quiet Sunday off, Sergeant Lopez spent the morning on the front porch of his modest home at 3886 Harney Street in Old Town. His neighbor and longtime friend John Brown saw the stoic policeman and pulled up a chair.

"Say, Joe," Brown said, "are you still working that case along the river? The one the farmer dug up?"

"Yes," the sergeant answered woefully. "Working is about all we are doing."

What his eccentric neighbor said next almost made the sergeant fall out of his chair.

"I saw the guy who buried that woman," Brown grunted.

"What's that!" the thirty-three-year-old raven-haired sergeant exclaimed.

"Take it easy, take it easy," Old Man Brown said as he waved a gnarled hand at his now very enthusiastic neighbor.

Even though the river bottom was remote, it was located within walking distance of Old Town, and Old Man Brown frequently took walks in the area. On one occasion, the old man said a man came running at him, waving his arms and telling him to go back.

"He was a crazy-looking fellow," Brown said. "And he talked crazy too. I asked him what was the big idea trying to shoo me away like that, and he said he was looking for ten sailors he was supposed to meet down there. I thought that was funny because I never saw one sailor, let alone ten, but I kept quiet because this fellow looked like a wild man. So we talked a little longer, and then I went away."

"Was the man you talked to a sailor?" Lopez asked.

"No, I don't think so. He wasn't dressed in a uniform."

"Did you see anything else?" the sergeant asked. "A machine? A wagon? Anything?"

Brown grinned at his neighbor's animated enthusiasm. "Sure I did. There was a spring wagon about a hundred yards up the river bed, and there was a big white bundle in the body of the wagon."

Lopez could barely contain himself as his emotions bounced between excitement and frustration. "Why didn't you come to me before this?" he exclaimed.

Brown ignored the interruption. "And I saw the same fellow again. He was down there three days later with a horse and light buggy."

Gritting his teeth, Lopez let the old-timer speak, but he had little else to offer. On the second sighting, Brown said he didn't speak to the mysterious stranger but insisted he could identify him again if they crossed paths.

Lopez was eventually able to get Brown to recollect the first encounter with the wild stranger as having been on June 17. It was exactly one month prior to the body being found.

MONDAY, JULY 19, 1920: First thing that morning, Sergeant Lopez met with his partner in the office of Chief Patrick. As he recounted the conversation with Old Man Brown, the chief paced nervously back and forth.

"The more we dig into this, the more involved it becomes," the chief bemoaned. "Up to L.A. we go, only to find the woman that's been positively fingered as being dead shows up alive and well. Now comes a crazy story from Old Man Brown that sounds just as believable. Where will it all end?"

The steely-eyed chief quickly snapped back to bureau procedure.

"That laundry mark is still going to be our best bet. Chadwick, I need to detach your partner for a robbery case, so you'll be going it alone for a while."

With Chadwick going from laundry to laundry, Chief Patrick resumed his part of the investigation by sending out letters to other police departments requesting information on similar cases.

Then came a reply from the Portland Police Department regarding the sailor who left town on June 10. PPD detectives determined the sailor traveled to Portland via the train and stayed with family during his visit. Railroad officials confirmed he was a passenger back to San Diego on June 21. With that bit of information, he was officially cleared as a suspect.

By now, the newspapers had gotten ahold of the murder mystery, causing well-intentioned citizens from all over the country to flood the chief's office

with unrelated correspondence about missing girls. Unfortunately for the bureau men, all of the correspondences had to be run down before they could be discounted as unrelated.

WEDNESDAY, AUGUST 11, 1920: Chief Patrick was losing his sense of time. He just realized he hadn't seen Sergeant Chadwick in two days when the missing bureau man suddenly burst in his office.

"I think I have that woman identified!" Chadwick exclaimed. "And I know who her husband is too."

When Chadwick began his search of the laundries, he knew he was retracing the steps of other policemen. But he had his orders and intended to carry them out. After crossing off location after location on his list, he finally struck pay dirt at a laundry on south Sixteenth Street just east of the downtown core. The manager, Robert Cathcart, grinned as the not so discreet bureau man walked in the door. "When am I going to be rid of you coppers?" he playfully asked.

Chadwick lowered himself into a cushioned seat "To be honest, I'd like to stay here for hours," he confessed. "It's cool here, your cigars are good and I like the cushions on your seats. But I have work to do. It's about that laundry mark, Mr. Cathcart. We still haven't linked it yet."

"We've checked it carefully, have we not?" Cathcart asked.

"Yes, but I'd like to go over it again with you."

Cathcart replied, "Consider it done. Let me get Miss Lillie Riggle. She was away on vacation when your investigators came by the first time.

Chadwick spread the pajama top across a table in the back of the laundry. After introductions were made, Chadwick explained the case and asked that Riggle examine it.

The woman lifted the garment and walked with it to an open window. For five minutes, she studied each part of it and then focused in on the embroidered laundry mark. "This garment has been through here," she said. "I recognize my work. That mark was placed by me right here in this laundry."

Chadwick could barely believe what he was hearing. Trying not to sound contrary, he replied, "That bit of clothes has been checked here before, Miss Riggle, but no record was found of the 2-0 mark."

"I can't help that," the woman insisted. "That garment has been through my hands, and I've worked here for the past seven years. Perhaps you didn't go back far enough in the files," she suggested.

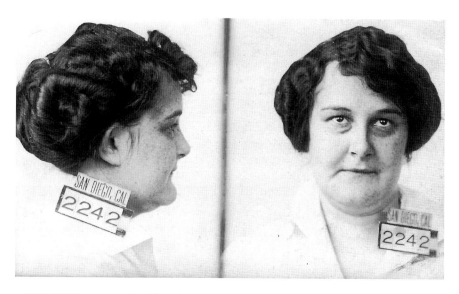

A 1915 SDPD vagrancy booking photo of Edna Mae Flash.

Acting on her suggestion, the manager and Chadwick went through the file piece by piece. Pad after pad of laundry slips was set aside, and then the men began delving into stacks of ledger books full of names. Suddenly Cathcart jerked upright in his chair. "Look," he exclaimed. "Here it is. The mark is so faint it's almost impossible to make out. It's a dead number that hasn't been used since January 1920."

Chadwick quickly jotted down the name "Edna M. Flash." Her address was an apartment house at Goldfinch Street and West Washington Avenue.

Within the hour, he was interviewing the landlady.

"Yes, I remember the Flash family. He was a chief petty officer in the navy, and the wife had two small dogs."

"How long have they been away from here?" Chadwick asked.

"I'd have to look that up to give you the exact date," the landlady answered. "But I think they moved sometime in February of this year."

"Do you have a new address?"

"I'm sure I do," the landlady said as she fumbled through a file full of papers. "Oh drat, I need my glasses to read it," she muttered as she pulled the sheet from the drawer.

"Give it to me," Chadwick demanded as he grabbed the paper from her hand. On it, in thin pencil lead, was the address "127 East Ash Street, San Diego, CAL."

It was that piece of paper Chadwick handed to Chief Patrick when he burst into his office on August 20. The chief looked at his watch and said, "We'll wait until five o'clock to give him time to get home from his ship. Then we will pounce."

5:00 P.M.: THE TWO men approached the front door of 127 East Ash Street. Chief Patrick gently knocked on the door. No answer. Another knock led the door to be opened by a short man dressed in civilian clothes. Behind him, in the darkness of the narrow hallway, the officers could see the form of a woman.

Chadwick tipped his hat toward the man. "Does Mr. Flash live here?"

The demure man in the doorway hesitated a moment. "Yes," he replied. "What do you want?"

"Are you Flash?" the chief demanded.

"Yes."

"And is that Mrs. Flash?" the chief asked as he pointed toward the woman.

The woman stepped forward from the shadows. She was barely more than a child.

"I am Mr. Flash's housekeeper," she answered.

"Where's your wife?" the chief demanded.

"She's in Arizona," Flash answered hesitantly. "Why?"

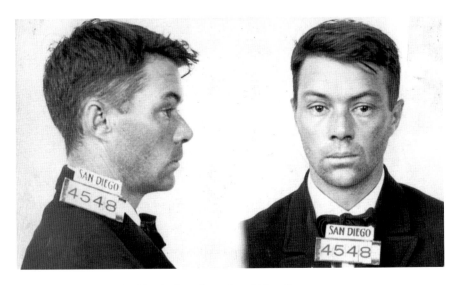

Thomas Flash was booked for the brutal murder of his wife.

"We're policemen," Chief Patrick said. "Both you and the girl will have to come to police headquarters with us."

For hours, Chadwick and the chief took turns questioning the man. He was a chief pharmacist mate on the USS *Prairie* and had been in the navy for eleven years. His story was that his wife, Edna, had gone to Arizona to visit an Indian reservation for her health.

"When did she leave?" Chief Patrick demanded.

"June 16."

"Have you been in contact with your wife?" Chadwick asked.

"Yes."

"May we see the letters?"

"No. I destroyed them all."

"Why?"

Flash just shrugged his shoulders.

The bureau men ultimately worked Flash for two days but still had nothing. He remained steadfast that his wife was in Arizona.

FRIDAY, AUGUST 13, 1920: Flash finally cracked.

"She's dead!" he cried. "But I didn't kill her. That was her body in the river bottom. I buried her in accordance with tribal custom. I'm part Indian. My wife and I were never compatible, and we always fought over her two dogs. I wanted her to get rid of them, but she never would. She was also addicted to narcotics. We quarreled all afternoon on June 16."

"About what?" Chief Patrick asked.

"Her dogs and her dope habit," Flash sobbed. "We kept up the fight into the evening until some friends came over to play cards."

"Did you stop fighting then?"

"No. Even then, she complained about me and said I abused her."

"What happened next?" the chief prodded.

"After they left, we called it a night. She went to bed, and I slept on a cot on the porch. We've slept that way for years. About two o'clock in the morning, Edna woke me up, and we began arguing again. She was driving me crazy. Then she made the remark that if she could find something to take she'd end it all."

"Go on."

"That got my goat. That's when I went to my dresser, found a capsule and threw it at her. I said, 'Here, take it if you feel that way about it. Why don't you do it?' She took the capsule and then died in convulsions."

Chief Patrick ended the interrogation and phoned Muir. Both men agreed Flash was probably guilty of murder; however, based on all they had, the confession was to nothing more than illegally disposing of a corpse, a relatively minor crime. Muir wanted to get more.

Several hours later, the deputy DA was at police headquarters personally interrogating Flash. Muir learned that part of Flash's duties as a pharmacist mate aboard the USS *Prairie* was to make medical preparations for surgeries. That included handling poisons. Flash said he was a sickly man fighting a lifelong lung ailment and had made a capsule of strychnine and atropine that he planned to take if his condition ever became so unbearable he could no longer function.

"So why didn't you report her death?" Muir asked.

Flash dropped his head. "Because it's traditional with my people that we bury our own dead. I was only carrying out tribal customs," he murmured.

Flash went on to explain how he hired a horse and wagon, wrapped his dead wife in sheets and drove her to the lonely spot along the riverbank. After burying her, he also buried the shovel. Flash said he bought the shovel from a local store but couldn't remember where. It would turn out he had good reason for the memory lapse.

Later that day, Flash led Chadwick, Chief Patrick and Muir to the spot where he had buried the shovel. It was less than one hundred yards from where his wife was found.

Back at headquarters, the shovel was cleaned off and examined. The tool was new, with no unique standard features; however, at the base of the stick, where the handle meets the metal, was a faint price mark.

Chadwick and Muir spent the rest of the day visiting hardware stores. They got lucky at their third stop. Examining the shovel, the proprietor said, "We just bought out the stock of another store, and I recognize these marks. This is how Mr. McKie marks his inventory."

With the information provided by the hardware store owner, the pair located McKie within the hour.

"Yes, this is my mark," McKie said. "And I remember this shovel. I sold it to a dark little man."

"Did you sell it around June 17?" Chadwick asked.

"No. It was some time before that."

"How do you remember this?" Muir asked.

McKie laughed. "Well, for one, I don't sell too many of these. Secondly, I remember this man. He was a dark little navy man who, if I recall, didn't know much about shovels. He left carrying the blade under his arm."

Murderer Thomas Flash bordered by Detective Sergeant Richard Chadwick on his right and Chief James Patrick.

"Would you be able to recognize this man if you saw him again?" Chadwick asked.

"Yes. He was a dark little man. I'm sure I'd know him again if I seen him."

Chadwick and Muir left the store, convinced as ever that the death of Mrs. Flash was not as her husband described. Why would have he purchased a shovel if he wasn't premeditating murder?

The investigators next located the livery stable that rented the horse and wagon to Flash. The proprietor stated Flash had come in three times: once with a large bundle and shovel in the wagon and the next time with just the shovel. When he returned the final time, he didn't have the shovel with him. Chadwick and Muir surmised the second trip was to destroy evidence, cover his tracks and dispose of the shovel. Muir now felt he had enough to introduce a premeditated motive.

Monday, November 15, 1920: Flash stood before the Superior Court facing a preliminary hearing for first-degree murder. Knowing that Flash was facing the rope at San Quentin if he was convicted, his attorney, John S. Cooper of Los Angeles, pressed forward the initial story of Flash being guilty of nothing more than illegally disposing of the body. The judge was unfazed. Flash was bound over for trial on Wednesday, November 17.

In the days between the preliminary and the trial, the DA's office requested an additional examination of Mrs. Flash's brain and other organs. Dr. H.A. Thompson conducted the analysis.

Then Cooper changed tactics. During jury selection for the trial, Cooper suggested he was seeking an insanity defense.

The trial opened with a flurry of helpful witnesses.

Neighbors testified that Mr. Flash had told them, days prior to his wife going missing, that she was going on a long trip.

The woman from whom Flash rented the house testified that Flash had told her his wife was on an Indian reservation in Arizona, but when she asked for her address, he stated any letters she wrote must be given to him. She further testified that Flash had given her a typewritten letter, which he said was from his wife but had come in his care and was addressed to the landlady.

The next witness was the proprietor of the livery stable.

Then, workers at the laundry were followed in quick succession by the hardware store owner.

Dr. Thompson was next to take the stand. He testified to locating a quantity of strychnine in the vital organs of Mrs. Flash. Dr. Coe Little declared the amount was more than enough to be lethal.

In defense of Flash, Attorney Cooper called a number of shipmates. When questioned, each witness stated Flash had been "acting queer."

Wanting to head off the insanity defense, Muir went on the attack during cross-examination. When questioning each of the shipmates, Muir asked them simply, "Do you believe Mr. Flash is insane?"

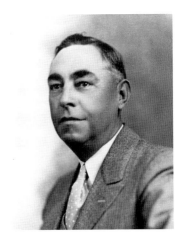

The persistence of Detective Sergeant Richard Chadwick solved the grisly Flash case.

Some seemed caught flatfooted by the question. Sensing some witnesses were friendly to Flash, Muir asked everyone the same question: "You believe Mr. Flash to be insane yet you accepted medicine prepared by him, did you not?"

Each answered "yes."

FRIDAY, NOVEMBER 20, 1920: The case went to the jury first thing that morning. Deliberations lasted for thirty minutes before delivering a verdict of guilty of murder in the second degree.

MONDAY, NOVEMBER 23, 1920: Mr. Flash stood before the court to receive his sentence: ten years to life in San Quentin.

# THE BLACK AND WHITE BANDITS

**W**ednesday, January 5, 1927: Los Angeles, California. When the United States National Bank at Twelfth and Olive Streets was knocked off shortly after opening, nothing distinguished the job as the first in a spectacular series of holdups across Southern California.

LAPD detectives reported four suspects pulled the stickup. As one robber waited in a car, his partners—two white men and a black man—strolled into the bank. One of the white men pulled a 1917 Smith and Wesson blue steel .45-caliber revolver and then quickly jumped the teller counter, demanding money from the terrified bank employees.

A second robber brandished a shotgun to herd the customers into a corner. As the duo held everyone captive, the black robber smiled as he went from teller to teller, helping himself to stacks of cash.

Not a word was spoken among the stickup men. With the cash stuffed into a nondescript burlap sack, the men casually walked to the waiting sedan and drove away.

The entire robbery took less than five minutes.

One bank employee copped a license plate. LAPD uniformed officers located the car abandoned three blocks away. A make on the registration revealed it had been rented in cash under a fictitious name from the Hertz Driveurself station on the far edge of town.

Several bank employees spent the afternoon at LAPD headquarters looking through a mug book of known stickup artists. Nothing.

TUESDAY, MARCH 29, 1927: The robbers struck again, this time at the Bank of Italy on the corner of Melrose and Western in the city of Los Angeles. Like the previous caper, the getaway car, a rented Cadillac, was recovered three blocks away. Like the January robbery, it, too, had been leased by a man using a fictitious name.

The suspects' description led newspapers across the Southland to dub the trio "The Black and White Bandits."

TUESDAY, AUGUST 23, 1927: Newshawks eagerly reported the gang's third robbery, also in L.A. While the time and date were new, the MO was the same: the gang came, they saw and they conquered. This time, the haul was almost $6,800 in cash (more than $96,000 in 2017 dollars).

Egged on by the press, which slammed the LAPD, the public was outraged. Something had to be done.

Then the bandits moved south.

In 1927, the city of San Diego could boast of never having had an unsolved bank robbery. With the ocean to the west and an international border to the south, the SDPD was famous for simply closing down the four arterial highways leading out of town and shaking down every car attempting to leave the city as patrolmen searched the neighborhoods. This earned San Diego the distinction as America's toughest town to rob.

TUESDAY, DECEMBER 27, 1927: The Security Commercial Bank at Fifth and University Avenue in San Diego was robbed of $6,208. Cops confidently swung into action.

Chief of Police Joe Doran was in his office when the robbery call came in. Having made most of his fifteen-year career in the Detective Bureau, he was more than qualified to assume charge of the case. His first action was to sound the alarm and close the highways leading out of town. Next, plainclothes men from the newly formed robbery unit were ordered to the scene.

As with the L.A. jobs, the getaway car was located nearby. Unlike the previous heists, the origin of the car wasn't immediately determined. Fingerprint men from the ID Bureau spent most of the day dusting the car for prints but ultimately determined the bandits were wearing gloves.

ID Bureau assistant superintendent William Menke searched the vehicle and discovered a tiny receipt card between the seats. Dated December 17

from the Pan American Oil Company of Los Angeles, it was the only shred of evidence left behind.

By the end of the day, it was painfully obvious that unlike every other stickup San Diego had ever endured, closing the roads to capture the robbers didn't work. The larcenous group had vanished somewhere within the city limits among the 147,000 people who called the area home.

WEDNESDAY, DECEMBER 28, 1927: The LAPD had been notified of the robbery in San Diego. A make on the plate came back to Lail's Auto Rental Service at 510 West Eighth Street in Los Angeles. LAPD dicks interviewed the proprietor and discovered, as in the previous jobs, that the car had been rented under a fake name.

The tiny receipt was traced to a San Diego service station; however, the attendant couldn't recall anything about the transaction.

With San Diego a racially segregated city, the bureau relied heavily on Detective John Cloud, who would ultimately retire as the SDPD's first black sergeant, to comb a predominantly black area of restaurants, bars, pool halls and hotels south of Market Street and east of Fourth Avenue.

Farther north, white officers went from hotel to hotel, shaking down known thugs and convicts. The sweep netted several fugitives and cleared a number of arrest warrants; however, none of those arrested were members of the Black and White Gang.

The sensational new coverage overwhelmed the SDPD with phone calls and walk-in traffic. The result was that everyone on the department wound up working long hours chasing dead-end leads.

SATURDAY, MARCH 3, 1928: The gang may have been feeling the heat was too much in San Diego. They struck the Citizens Trust and Savings Bank in Los Angeles.

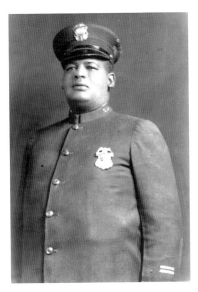

Officer John Cloud combed the gritty flophouses and pool halls of Darktown in pursuit of the Black and White Bandits.

TUESDAY, MAY 22, 1928: The euphoria of the gang moving north proved to be short-lived when the Black and White Bandits struck the First National Bank at Thirtieth and University. SDPD robbery detectives would later discover the bandits used three cars for that specific job. The first was traced to a Los Angeles livery one week earlier. The second was rented in San Diego under a false name on the day of the robbery. The third car allowed them to safely pass through the roadblocks and head back to Los Angeles.

As frustrating as it was, the bandits were starting to get overconfident. In the last rob job, one of the stickup men was especially talkative. As he wielded a sawed-off shotgun, a white robber barked toward his victims, "Be good little boys and girls and no one gets hurt."

Steven Stone, an employee of the County Hospital, proved to be the best clue to the May 22 case. He may also have been the most frustrating. Stone was crossing the street leading to a northbound highway when he was hit by a large sedan driven by a black man. Two white men were also in the car. Stone reported one of the men had a shotgun draped across his lap. Unfortunately, Stone waited more than a day to provide the information to anyone.

By now, banks across the Southland were on high alert. Armed guards were hidden in branches across San Diego and Los Angeles. On two occasions, minor stickup men had their tickets punched when they were met with blazing guns.

WEDNESDAY, SEPTEMBER 19, 1928: The bandits returned to San Diego, this time knocking over the Bank of Italy at Felton Street and Adams Avenue. The getaway car was located seven blocks away.

The best witness in this case turned out to be a six-year-old boy. He reported seeing three men—two white men and one black man—exit the car and carry a suitcase down the street. Detectives traced the getaway car to Lail's Auto Rental Service, this one located at 746 Hope Street in Los Angeles. The franchise was across town from the Lail's that had provided the getaway cars in previous robberies.

The press went into a frenzy. Completely disregarding past bureau successes, newspapers assailed the police department. Daily the headlines screamed, "Why Can't the Inept Men of the SDPD Catch These Bandits?"

Chief Doran bore the brunt of the abuse. His office at 700 Second Avenue was bombarded with phone calls and letters. Some of the letters demanded his resignation; others offered "expert" advice.

Then came a break. Sheriff James Smith of Fallon, Nevada, contacted the SDPD with information on two white men and a black man arrested for robbery in his county. Detectives from the SDPD and the LAPD sped east to interview the trio. They returned empty-handed. Evidence and alibis proved they were not the Black and White Bandits.

Two more L.A. stickups—one in November and the other in December 1928—reinforced just how little the police had on the gang.

TUESDAY, MARCH 19, 1929: The gang had been operating for more than two years. Just after 10:20 a.m., a large Cadillac pulled up to the curb in front of the First National Trust and Savings at Thirtieth and University Avenue. It would be the second time the gang hit this specific San Diego bank.

As the leader of the gang was exiting the bank, the branch manager, Hal Royle, had enough. Armed with a .38 revolver, Royle opened fire on the startled robber. The bandit turned and fired back as bank employees and customers cowered in fear. As the robber bolted for the Cadillac, another bank employee joined in the shooting with a 30-30 rifle he had stashed in his office.

By chance, Patrolman Edward Johnstone was at a callbox across the street. When he saw the bandits, he pulled his service revolver and joined the bank employees in the lead fest directed at the robber.

One gangster jumped from the Cadillac and attempted to shoot back at Johnstone.

Motorist George Sinclair, oblivious to the unfolding mayhem, drove between the Cadillac and the policeman just when the bandit pulled the trigger. The errant bullet tore through Sinclair's car, narrowly missing his head. Apparently not one to take such attacks lightly, Sinclair reached under his seat, pulled a .22 and began shooting back at the big Cadillac as it attempted to drive away.

Down the street, Roy Neblett, the proprietor of a radio shop, saw the mayhem and joined in the shooting with his own revolver.

A barber also ran from his shop and emptied his handgun at the Cadillac as it vanished around the corner.

Detective Lieutenant Malcolm Berrie was in his office when the call of the latest robbery came in to police headquarters. He quickly contacted Chief Doran. Within minutes, the SDPD teletype was contacting the La Jolla and East San Diego substation with Doran's orders: "CLOSE ALL ROUTES OUT OF THE CITY AND GET ALL POLICEMAN ON THE STREETS."

Like with all the previous robberies, the getaway car was located several blocks from the crime scene. This time, the car was riddled with more than twenty bullet holes of various calibers. An exhaustive search of the car did not locate any blood. How the bandits managed not to get struck seemed a mystery.

With the city sealed, patrolmen began canvassing the neighborhoods.

Outpost crews were also busy. Every car attempting to leave the city was stopped and searched. As the bandits were known to be armed and dangerous, each stop was conducted by officers with their side arms drawn. Some citizens were outraged and promised to call the mayor and have the officers' jobs. Others took up seats at the roadblocks so they could watch a gunfight when the bandits tried to make it through.

Back at headquarters, Lieutenant Berrie was up to his eyeballs fielding tip calls. In the days before computers and radio-equipped cars, he was relegated to copying each tip on a scrap of paper and then waiting for officers to phone in for assignment.

One of the better tips was a sighting of a black man and two white men going into a small house at 3244 Clay Street in Logan Heights. Lieutenant John T. "Pete" Peterson quickly assembled a gang of bureau men—Mike Shea, George Sears, Tommy Osbourne and Ray Little—and ordered them to grab cars. Along the route, they were joined by motorcycle officer Frank Merritt. The men parked two blocks from the target house.

Keenly aware they were in a predominantly black neighborhood, the Caucasian men in dark suits and fedoras that screamed *police* cautiously approached the house, silently hoping no one would look out the window. Officer Merritt jogged down the dirt alley abutting the rear of the house to cover the back.

Situated to the rear of 3242 Clay, the target house looked peaceful enough. Detective Shea and Detective Little quietly crept onto the porch. Holding his .45 pistol in one hand, Shea knocked on the front door. No answer. Shea knocked again. A nervous black man with beady eyes cracked open the door.

"What do you want?" the man demanded.

Shea threw his shoulder into the door with such force it knocked the man backward. In almost one motion, Shea grabbed the man and shoved him onto the porch toward Detective Little as he continued into the small living room. There, Shea found himself looking at a sawed-off shotgun leveled at his chest.

"Stick your hands up and drop that rod or I will blast you to hell!" the gunman barked. He had Shea dead to rights.

Shea quickly reached forward and grabbed the shotgun with one hand and then muscled the barrel upward toward the ceiling. With his other hand, he shoved the .45 into the crook's stomach.

"I'm a police officer. Get your own hands up. You're under arrest," Shea shouted back.

No one will ever know what was going through the robber's mind as Shea demanded the gunman drop his weapon. The slightest bit of pressure on the trigger could have taken Shea's head off. Perhaps it was a fear of being shot in the chest by Shea if the shotgun went off that made the robber drop his weapon. The standoff was over as quickly as it had begun.

Mike Shea earned the respect of a gang of hardcore stickup men when he burst into their hideout and took down a shotgun-wielding robber.

Well aware that there were other men to account for, Shea grabbed his prisoner and used him as a human shield to move toward the back of the house. As the bureau men burst into a back bedroom, they found another armed robber standing next to the bed.

"Drop your weapon!" Shea commanded. His .45 was pointed directly at the robber. Behind Shea were several other policemen, also pointing guns. The robber wisely surrendered.

For a moment, the only sound in the room was the sequential clicking of handcuffs as Peterson and Osbourne cuffed two white men, Lynn Keith and John Foster, of the Black and White Bandits.

Back at headquarters, Paul Hayes led the interrogations. An imposing figure standing well over six feet tall even without his trademark hat, Hayes was widely regarded as the best interrogator on the SDPD. He didn't disappoint.

The trio quickly confessed to ten bank robberies in San Diego and Los Angeles. They also dropped dime on a fourth robber who had been involved in several L.A. jobs. The LAPD used the information to make an arrest the next day.

During his interview with Walter B. Miller, the black bandit, Hayes asked, "Why did you follow Keith into a life of crime?"

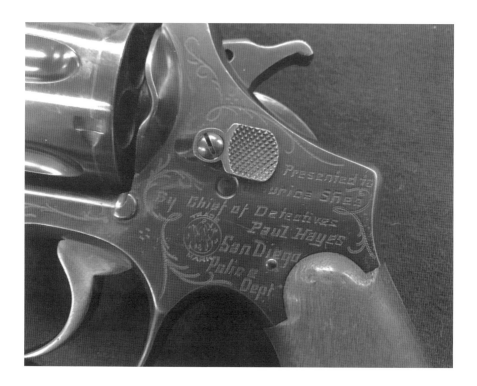

The prized possession of the Black and White Bandits. Paul Hayes presented the weapon to Mike Shea for taking down one of the most dangerous gangs in state history.

Miller paused and then answered, "Well, boss, Lynn was the bravest man I'd ever met except for one."

"Who do you mean?"

Miller smiled. "That cop who arrested us."

Days later, a host of eyewitnesses and bank employees came to police headquarters for a live lineup on the three suspects. An overwhelming number made positive IDs. The airtight cases made for rapid trials. Lynn Carter Keith, Walter B. Miller and John J. Foster were each handed terms of five years to life in Folsom. The men were also tried in Los Angeles Superior Court and received almost identical sentences, to be served concurrently.

## CHAPTER 7
# MISSION HILLS MAYHEM

**W**ednesday, January 12, 1927: It was a tranquil morning in the tony neighborhood of Mission Hills. Nestled on rolling hills overlooking the birthplace of San Diego, Old Town, the tree-lined streets were dotted with some of the city's finest homes.

Shortly after 8:00 a.m., the six-year-old son of prominent businessman B.G. Showley answered a knock on the door of the family residence at 1859 Fort Stockton Drive. Standing before him on the porch was William Smith, a large black man with a deranged look about him.

"Where's Eula?" Smith demanded.

The small boy looked meekly over his shoulder toward the staircase leading to the second floor. The lad pointed at the steps and then watched Smith charge around him and toward the upstairs.

Mrs. Showley was in bed when Smith burst into the master bedroom waving a .38 revolver. The maid, Eula Caldwell, had been serving breakfast to Mrs. Showley. Looking up to see Smith caused her to slide to her knees and under the bed.

Smith fired twice. Eula was struck in the chest and the leg.

As Eula collapsed, Mrs. Showley bolted for the door, raced down the stairs and snatched her son. Another gunshot rang out. Police would later learn Smith shot Eula in the leg again.

Constable George R. Cooley just happened to be walking by the home when the terrified woman raced out. The father of (then) Detective Sergeant George Cooley Jr. and a former SDPD sergeant with a reputation for stellar

Absent a personal collection of news clippings maintained by its owner, memories of the Fort Stockton shootout at the stately home have been lost to history.

bravery, the constable drew his gun and raced toward the house. Two more shots from the upstairs window cut the grass next to him. As Cooley dived for cover, Showley ran to a neighbor and called police.

Within minutes, the shrill of sirens pierced the air from all directions. Uniformed officers flooded the scene. Plainclothes detectives also began to arrive.

Captain of Detectives Paul Hayes was the senior ranking officer on scene until Chief Patrick arrived and assembled a squad of men, including Patrol Captain Arthur Hill, Sergeant Robert Newsom and Detective Sergeants Malcolm Berrie and Herbert Hill.

Without the resources of a SWAT team or active shooter tactics, Captain Hayes quickly formulated a plan and then led the men into the bottom floor of the house. Peering up the staircase, Hayes could see Smith standing on the second-floor landing.

"What's going on up there?" Hayes shouted.

"There's a sick woman up here," Smith yelled back.

Hayes moved cautiously toward the stairs. Smith leveled his gun at the captain and pulled the trigger. The weapon misfired. Hayes lurched forward

to try to get up the staircase. This time, the gun fired and sent a bullet into the wall behind the captain's head.

Hayes leaped across the foot of the staircase to safety. Using his left hand, the southpaw Hayes drew his pistol and returned fire, striking Smith in the hand.

Sergeant Berrie, who was naturally right handed, stood on the opposite side of the staircase and fired three shots toward the second floor. Smith jumped backward out of sight.

Hayes pulled the pin on a tear-bomb. Using an exaggerated overhand toss, he lobbed the smoking, spewing grenade to the top of the landing. A thick fog of noxious gas quickly began to fill the second floor.

Then came silence. Finally, Smith blurted out, "What will I get for this?"

Hayes shouted back, "I don't know."

Several more minutes of silence.

Finally, Hayes barked, "What are you doing up there?"

"Praying," Smith nervously replied.

With Smith still on the landing, Lieutenant E.L. Miller and SDFD engineer A.E. Geisler carefully leaned a fire ladder against the side of the Showley house. As Geisler held the ladder steady, Miller crept to the top and peered into the bedroom window. Eula was on the floor in the middle of the room, holding her wounds.

Geisler propped another ladder up against the side of the house and joined his partner at the window. With Smith nowhere in sight, the men quickly hatched a plan to climb in and lower Eula to safety.

The men slid through the window and onto the bedroom floor in single file. They quickly reached Eula.

"Can you move?" Miller whispered.

Eula shook her head no.

Miller and Geisler picked Eula up and were moving to the window when they suddenly stopped cold. Smith was standing in the doorway with his double-action revolver aimed directly at them.

The men looked at Smith and then at the window. Figuring they would make it to the window or die trying, they carried the injured woman out and lowered her down to the ground. Smith simply stood and watched.

As soon as Eula reached the waiting arms of the policemen outside, the uniformed cops let loose with a barrage of lead from two directions. Smith yelled in fear and then ran from the master suite and into a second bedroom at the front of the house. Diving headfirst into a closet, Smith stuffed a coat under the door to block out the teargas.

Chief James Patrick was in the living room below. He heard Smith's panicked footsteps across the hardwood floor and used the sound to track the gunman's location. Raising his Krag-Jorgensen rifle, the chief began blasting into the ceiling above him. As plaster rained down on the chief's head, Smith danced around inside the closet as bullets ripped up through the floor below him. The sudden addition of .38 ventilation holes allowed the teargas to dissipate.

Armed with a large fire axe, Sergeant Alvin Lyles Jr. methodically crept up the stairs and into the front bedroom. Bullet holes were in the floor, and he could see his police comrades down below him. No one made a sound. The strapping twenty-nine-year-old blue-eyed sergeant raised his axe and then took a powerful swing at the wall. The delivery knocked a gaping hole.

As he pulled the axe back for another swing, Smith peered out of the hole and made eye contact with Lyles. A decorated World War I veteran who was used to close-quarters combat, Lyles drew his pistol just as Smith burst from the closet shooting. Detectives would later discover Smith had located a stash of ammo inside the closet and reloaded.

Smith bolted from the room. Sergeants Berrie and Newsom were waiting on the second-floor landing. Berrie dropped to one knee and opened fire. Smith fired two more times before police bullets shredded his body and he fell to the floor.

The three-hour siege was over. Smith was dead.

Smith was transported to the Johnson-Baum mortuary. Dr. Schulyer Kelly conducted the autopsy. The postmortem revealed Smith had been shot eight times, but only one wound—a severed aorta—was fatal.

The police ambulance rushed Eula to Mercy Hospital. She arrived having lost a lot of blood. Initially, doctors forecast her condition as grim and didn't expect her to live through the night. Fortunately, she made an almost miraculous recovery.

The police department provided a press release to the media on the background of William Smith. Sentenced to jail for ten days for reckless driving on November 9, 1926, Smith was released on November 19 only to be rearrested on a warrant charging abuse on Eula Caldwell. That case was later dropped.

A cocaine addict and hop head who originally hailed from the Imperial Valley, Smith had been divorced for several years. In her petition to the court, fifty-year-old Nannie Smith described her husband as a former rubbish man who lived at Thirtieth and Martin in Logan Heights. She cited her husband's obsession with Eula as the primary cause of their marriage failing.

Paul Hayes almost lost his life in the Fort Stockton shootout.

The former Mrs. Smith appeared at police headquarters a day after the shootout. Alleging a police conspiracy to deprive her of property, the gunman's ex-wife demanded Chief Patrick provide her with her former husband's car.

Mrs. Smith wasn't the only issue.

Outraged at the damage done to their home, the Showley family filed a damage claim with the City of San Diego. Citing a lack of bullet insurance and a reckless disregard for their personal property, the family requested the city reimburse them for the $5,000 worth of repairs needed to their home. To justify his claim, Mr. Showley rhetorically asked the media, "Suppose there was a fire in your home and the fireman's hose did more water damage than the fire ever could have. Wouldn't you be entitled to compensation?"

The city didn't buy the argument. The claim was flatly denied. Deputy City Attorney F.M. Downer told the press, "This claim is without merit. If we were to pay people every time an officer damages something in the performance of their duty, police would soon stop doing their duty out of fear."

The acting mayor, Councilman Louis Maire, backed up the city attorney. "I cannot think of this as a financial matter," Maire declared. "I believe the lives of the Showley family were saved by our policemen. The payment of any damages would establish a danger[ous] precedent that we must not do."

# MURDER AT THE CALIFORNIA THEATRE

Sunday, May 6, 1928, shortly before 11:00 p.m.: An urgent telephone call into San Diego police headquarters broke up the monotony of an otherwise quiet weekend. There'd been a shooting at the California Theatre located on the corner of Fourth Avenue and C Street. The theatre manager, James F. Malloy, had been shot and gravely wounded during a robbery.

Night robbery detectives Hugh Rochefort and George Cooley were dispatched to the scene. Following close behind was the police ambulance and Dr. Paul Brust, the SDPD's surgeon. They arrived within minutes of the call.

As Dr. Brust tried in vain to stem the bleeding still gushing from Malloy's severed artery, the detectives plied witnesses with questions.

Miss Eula H. Schneider worked as the courtesy girl for the theatre and had interacted the most with the stickup man prior to his shooting Malloy. Schneider told detectives the man had approached her and demanded to speak to the manager of the theatre. The robber stated he had a message to deliver. Schneider stated the robber smelled of liquor as he spoke. Schneider returned to her duties after walking the robber to the manager's office and announcing his presence. Schneider said she then heard a shot and saw the robber run from the theatre waving his gun.

Cooley asked, "Did you get his license plate?"

Schneider answered, "No, but I told two young fellows who were in the foyer to do so." As she spoke, she pointed out the men to the officers. Detectives soon learned the suspect's plate was California 1-544-022.

Despite its majestic architecture, local significance and long-forgotten murder, the once majestic California Theatre at Fourth and C Streets now awaits a wrecking ball.

Rochefort phoned headquarters for a make on the plate and a countywide all-points bulletin. Because police cars of the era did not have radios, putting out an APB was nowhere near as effective as today.

Paul Hayes was summoned from home to lead the investigation. He immediately ordered all officers back on duty. The sheriff was requested to cover all roads exiting the city.

Then came news from the hospital: Malloy was DOA. The bureau men were now looking for a killer.

Eyewitness descriptions of the killer varied wildly except for one particular: he had an unusually long neck. West Gregg, a friend of Malloy's, was also a witness and provided another exceptionally important clue: the killer's hands were tattooed with either letters or figures.

Meanwhile, at Fifth and University Avenue, motorcycle officers Thomas Remington and Artemas Comstock were parked at a callbox for their hourly report to headquarters. Suddenly, Remington saw the suspect's car, a black coupe, race by. Comstock leaped into the saddle of his Harley Davidson and gunned the motor. Remington was right behind him.

Despite the best efforts of Dr. Brust, SDPD's best police surgeon, theatre manager James Malloy was declared dead on arrival at Mercy Hospital.

The car sped down University Avenue, blowing a stop sign at Fourth Avenue. The motorcycle officers were in hot pursuit close behind when Remington noticed the license plate didn't exactly match. It was 1-454-022. There were also two men in the car versus the solo killer seen fleeing the California Theatre.

Suddenly, what looked like an arrest for murder was simply an unsafe nocturnal driver. The car pulled to the curb. The motorcycles dropped in behind. Comstock was already thinking of what violations to put on the traffic ticket he'd be issuing as he dismounted his motorcycle.

A shot rang out from the car. Comstock was hit in the right shoulder. As he reeled backward and fell into the street, his motorcycle fell on top of him. Another shot rang out. Remington pulled his service revolver and fired point blank into the rear window of the suspect's car as it pulled back onto the street. Remington could clearly see it was the passenger who was shooting.

As the gunman traded rounds with Remington, Comstock reached across his body, pulled his revolver with his left hand and fired three rounds at the fleeing car. Remington saw one of the rounds strike the car and the driver slump forward and then straighten up and continue to drive away.

Officer Beaty pulled his prowler up to the downed motorcycle officers.

"Take care of Comstock!" Remington shouted, "I've got to get that license plate to headquarters, then I'm going after that car."

A mutual aid call was put out to all countywide agencies. Policemen and deputies soon swarmed the area for a street-by-street search.

Within minutes, the car was located along the curb of a desolate street rimming the edge of a canyon. It was unoccupied; however, blood was found inside.

Officers armed with rifles took up positions on the north, east and south of the canyon as patrolmen entered from the west. If the suspects hadn't yet made it to the other side, they were sure to be captured.

Rochefort was the first to spot a bloody cap at the bottom of the canyon. As he examined it closer, his partner, Deputy Blake Mason, exclaimed, "Look here!" as he pointed to a matted area of grass. "The gunmen must have rested here. They can't be far."

Rochefort shined his flashlight toward a worn path leading to the top of the canyon. An apartment building was directly at the end of the path.

"Let's check there," Rochefort said.

The men trudged to the top to find the lowest floor of the building was a storage area. The nearest door to the canyon was standing open. The policemen cautiously shined their lights into the room. It was empty.

Despite witnessing his partner being shot, Motorcycle Officer Thomas Remington bravely chased the killer's car into the night.

Other policemen had joined Rochefort and Mason. Officer Louis Chauvard shined his flashlight along the wall of the building.

"Look at this," Chauvard whispered. Red smears of fresh blood were on the frame of the door to another storage room.

Realizing the danger of entering a room single file, the officers quickly threw open the door and rushed in. They were standing in the entryway to a large cavernous cellar and were sitting ducks for someone to open fire on. Based on the evidence, the shooter was badly wounded and probably close by. They needed to be ready for a desperate fight with a cornered violent man.

Rochefort shined his light into the cellar and shouted, "Give up. We have you surrounded. There's no way out."

The men listened for a response. It was eerily quiet.

Rochefort and Mason were armed with sawed-off shotguns as they walked side by side to lead the other officers farther into the cellar.

Rochefort spied a pile of discarded construction materials. More blood was clearly visible.

The officers shined their lights across the walls of the cellar. Nothing. Suddenly, the men heard a noise behind them. As they spun around, they realized it came from the vicinity of a large brick chimney. There, barely

visible, were the foot and lower leg of a man extending from behind the brick tower.

"Come out of there!" Mason assertively shouted.

The policemen trained their guns on the vent. The foot drew farther back. Mason and Rochefort stepped forward and fired almost simultaneously.

A dim figure stepped into the beam of the flashlight. The policemen fired again. The man crumpled to the floor of the cellar, dead.

Beaty grabbed the body and dragged it into the center of the room. A hasty examination of the man didn't find tattoos on his hands. Malloy's killer was still on the loose.

The ID Bureau ran a make on the corpse. Fingerprints identified him as a career criminal named Otto Andrew Morrissey with police contacts in Long Beach and San Pedro. Even though he was from out of town, he was no stranger to San Diego law enforcement. On the morning following the murder of Malloy, several people had phoned in tips about Morrissey as a possible suspect. He'd been seen acting suspiciously in the days prior to the murder but was always spotted alone.

A wire from the California Department of Motor Vehicles revealed the getaway car, a Pontiac, was registered to Horace Brown of San Pedro, a Los Angeles suburb on the south end of the sprawling metropolis of 1.2 million people.

MONDAY, MAY 7, 1928: Harry Kelly was dispatched to San Pedro to meet with the LAPD to track down the registered owner of the Pontiac and learn more about Morrissey and any contacts he may have had with an associate with tattooed hands.

Partnered with LAPD detective Lieutenant Gentry, Kelly soon located Mrs. Morrissey and informed her of her husband's death.

While questioning her, Kelly learned she'd last seen her husband on May 6, the day of the murder, and he'd been drinking. Kelly also learned Morrissey left the house alone but was armed with a .41-caliber revolver. Mrs. Morrissey said she didn't know of a long-necked, tattooed man her husband associated with.

The address for Horace Brown checked negative, but the men were able to speak to his neighbors to determine he was staying in a San Pedro hotel.

Brown turned out to be a decrepit man. At first, the codger was uncomfortable talking to the lawmen.

"I don't know no man with tattooed fingers," he declared.

Gentry responded back with, "You know Morrissey, don't you?"

"Yes, I know him," Brown answered begrudgingly.

"And you loaned him your car, didn't you?" Kelly insisted.

"That's no crime, is it?" Brown retorted.

"No, it's not," Kelly fired back. "But when he used that car in a holdup to kill one person and shoot a policeman, it comes mighty close."

The sick man jerked himself up on one elbow. "What's that?" he demanded.

"Don't you read the newspapers?" Gentry asked.

"Not today. No. So, Otto's dead, eh?"

"Yes, he is," Kelly answered. "And we want to know who his partner is."

Brown pointed a shaky, gnarled finger toward a box on the dresser. "Hand me that."

The oldster searched through the box until he pulled out a sheet of paper. It was a merchant seaman's certificate of American citizenship in the name of James Durant. At the bottom of the page was a typed description, including a reference to "True Love" tattooed across his hands. The top of the page bore a fingerprint and photograph of a long-necked man.

"That's the fellow who was with Morrissey," the old man declared.

The policemen raced back to the LAPD station, eager to follow up.

As Kelly phoned San Diego with his information, Gentry was busy scanning arrest logs for an address on Durant. He quickly located a report from April 25, 1928, in which Durant was arrested for possession of alcohol—a violation of Prohibition.

There was further luck. An LAPD officer on duty at the time personally knew Morrissey and remembered arresting him for beating his wife. When the officer searched Morrissey, he recovered a .41-caliber revolver and impounded it. According to the booking log, Mrs. Morrissey came to the station and demanded the gun back.

Kelly raced back to San Diego to find the ID Bureau had already compiled a record on Durant. He was a career criminal with a number of aliases.

An enlargement of his merchant seaman photo was made and shown to the witnesses at the California Theatre. Each identified Durant as the shooter.

Hundreds of wanted posters were hung across Southern California. Meanwhile, the ID Bureau teletype sent fliers as far away as coastal towns in South America.

The U.S. postal inspectors were notified to monitor Durant's associates for any incoming mail from the killer.

It seemed certain Durant would quickly be captured.

MONDAY, FEBRUARY 27, 1933: It had been almost half a decade since the murder of James Malloy and the shooting of Officer Comstock.

Three well-dressed men walked into a dry goods store in Logan, Utah. Two of the men distracted the clerk while another shoplifted.

The store proprietor called police as soon as the men left. Providing them with a good description and direction of travel, deputies of nearby Box Elder County were able to quickly locate and arrest the three men.

WEDNESDAY, MARCH 1, 1933: SDPD chief of police Robert Newsom received a telegram: "James Durant, aka Ralph Hill, subject of your circular, case B878 is under arrest in Brigham, Utah. Do you want him?"

The hunt for the tattooed killer was over!

SATURDAY, MARCH 4, 1933: As Harry Kelly and District Attorney Thomas Whelan boarded a train to Utah to bring the killer back to face San Diego justice, SDPD bureau men needed to track down the witnesses to the five-year-old case. Their best witness, Eula Schneider, was married and living in L.A. when detectives caught up to her.

Officer Comstock was still on the SDPD and was most eager to reacquaint himself with Durant.

Durant confessed to Kelly on the train ride back to San Diego.

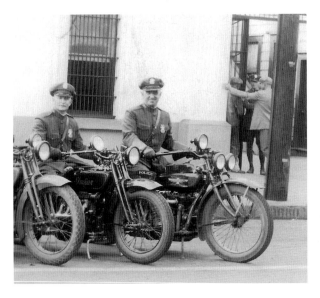

Motorcycle Officer Artemas Comstock (*right*) was still on the SDPD and helped finger James Durant for shooting him and for the California Theatre murder.

FRIDAY, MARCH 10, 1933: Durant formally entered a guilty plea to one count of murder, one count of attempted murder of a police officer and attempted robbery. He was handed a life term in Folsom.

# HOT WATER

*Agua caliente is Spanish for "hot water." In this specific case, it should have meant cold blood.*

**M**onday, May 20, 1929: Mr. R.W. Smith and Alexander Bird, employees of the Union Ice Company, were driving south toward National City. The small town of less than ten square miles was the second oldest in San Diego County, and as an underdeveloped patch of farmland and industry with its northern border straddling the south of San Diego, it was the ideal location for one of Union's ice-producing plants.

The morning was bright, typical of San Diego's warm golden sunshine. Suddenly, the tranquility was shattered by the distinct rattling of gunfire—staccato shots reminiscent of Al Capone's gangland mayhem in Chicago. Fifty feet south, a large Cadillac coupe limped to the side of the road and stopped. A Ford touring sedan, more styled after a working-class man, pulled alongside the much more elegant Cadillac.

What came next shook the mild-mannered businessmen to their core. Two dungaree-clad men launched from the Ford and opened fire. One trigger ran to the end of the Cadillac, shooting as he moved. The other stood on the running board and let loose a barrage of bullets straight from the hot end of a Tommy gun. Only two shots came from the Cadillac as the chopper shredded the men inside.

Then, as quickly as it began, it ended.

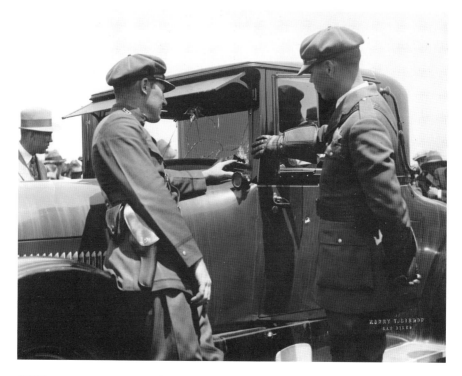

SDPD motorcycle officer Arleigh Winchester and California Highway Patrol officer Leslie Ford examine the Agua Caliente death car in San Diego's bloodiest robbery homicide.

One of the triggermen jerked open the trunk of the Cadillac and plucked out a heavy satchel. After flinging it into the Ford, the men sped north toward San Diego, but not before Smith copped the plate: 5E4132.

Smith threw his Ford into gear and rushed toward the nearest telephone. Detective William O'Connor took the call. He immediately summoned fellow gumshoe Edward Dieckmann to race to San Diego's bloodiest murder ever.

The scene was on the narrow road connecting the two cities. The dicks arrived to a road packed with cars and the curious. Inside the Cadillac, the cops found Jose Borrego and Nemesio Monroy riddled with bullet wounds.

A quick check of the plates revealed the Cadillac belonged to the Hotel Agua Caliente in Tijuana. The men were money car guards and had left the hotel earlier that morning with the weekend deposit, later revealed to be $80,000 in cash. In 2017 dollars, the sum equaled more than $1.15 million.

The detectives quickly surmised the ambush was part of a well-planned act carried out by professionals. To catch them would not be easy.

Smith and Bird weren't the only witnesses. Two women were driving along the road when they were overtaken by the Ford. With no regard for the safety of anyone else, the gunmen began shooting at the tires of the Cadillac. If the women felt helpless watching the guards slaughtered alongside the road, they quickly made up for it when they took off after the Ford. They chased the car onto an unpaved street but then backed away when one of the gunmen pointed a pistol at their car.

Armed with a description, a license plate and a direction of travel, the detectives quickly put out an all-points bulletin and placed a telegram to Sacramento for the Ford's registration info.

Within half an hour, Detective Sergeant Joe Doran, who'd just completed a two-year term as chief of police, and Detective Hugh Rochefort followed the tire tracks—made unique by the skidding of the car at high speed—to find the unoccupied Ford in front of a house at Edgemont and B Streets. They were approximately fifteen blocks from the scene of the murder.

Detective Rochefort searched the car as Doran canvassed the neighborhood. He quickly located a man trimming the front lawn of his home. Within a minute, Doran learned of a third person waiting in a switch car, but the witness hadn't copped a plate. It seemed a dead end.

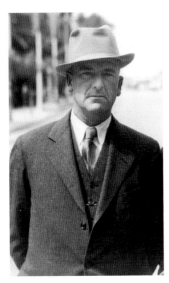

Back at the car, Doran discovered the black paint car was fresh and masked the original color of gray. Inside were a pair of dungarees and two pairs of sunglasses. Most interesting, was a discarded gray cap and a .45 shell casing in the driver's compartment.

On the street, almost buried in the dust, Doran found a Ford ignition key numbered A935. The key fit the Ford door lock. Unfortunately, that was the extent of their luck.

The physical description was so generic it could have fit a thousand people. The Department of Motor Vehicles wire revealed the car had been stolen from a local garage twelve days earlier. The plates had been stolen from a car in Northern California. The only real clue was the machine gun used to slaughter the couriers.

Detective Sergeant Joseph V. Doran.

Detectives regrouped at police headquarters.

Harry Kelly held up the sunglasses to the sunlight beaming in the window. There, on the corner of the lens, was a latent fingerprint. He quickly summoned Walter Macy, the superintendent of the Identification Bureau, with orders to develop the print. Even if a clear print could be lifted, Kelly knew it would be of little value without a suspect to compare it to. They had to develop a suspect.

Then came another break. Paul Hayes plucked a red hair from the inside of the cap. Based on the length, the detectives deduced it belonged to a woman. From the looks of it, they were now dealing with a gang of killers.

The SDPD Records and Identification Bureau began wiring every police department and sheriff's office west of the Mississippi River requesting information on the gang. A $5,000 reward was quickly posted by the Agua Caliente Hotel for information as well.

Despite their efforts, the break in the case came from a little girl who had been playing in the area where the getaway car had been dumped. On May 21, 1929, the little girl approached a milkman with an odd-shaped key.

"Look at what I found, Mr. Weston," the little girl declared as she presented the key. "Will it fit your car?"

The milkman took the key and gave it to his brother, Officer Bruce Weston, who gave it to Harry Kelly.

As uniformed patrol officers fanned out across town to reported sightings of the killers, detectives were equally busy with eyewitnesses coming forward. To a person, they proved to be of no value. In many cases, the reports came through nowhere near where the crime occurred. One man actually confessed to being the killer. After detectives determined he was simply a publicity seeker, he was marched into the police court and sentenced to jail for filing a false report.

Then came a worthwhile clue. Snitches on the street were rumbling about a man known only as "Captain Jerry" who had a machine gun. A search of arrest records developed a possible suspect: a tugboat operator and occasional rumrunner named Jerry Kearney who lived less than fifty feet from where the second key had been recovered.

WEDNESDAY, MAY 22, 1929: Chief Kelly and Detective Sergeants William O'Connor and John Peterson met with state pharmacy inspector William Luchenbach two blocks from Kearney's house. Unable to get a search

The Kearney home at 3559 Villa Terrace has changed little since the day Chief of Detectives Harry Kelly and his men kicked down the door.

warrant to toss the house for the gun, Kelly had the pharmacy inspector obtain one based on a narcotics investigation.

That afternoon, the policemen approached the Kearney residence at 3559 Villa Terrace. Peterson and Luchenbach went to the front; Kelly and O'Connor covered the back. Pulling his revolver from his leather shoulder holster, Kelly rapped on the door. A female voice answered.

"Who is it?"

"Police. Open the door."

"Have you got a warrant?"

Kelly answered by kicking the door off the hinges. He then rushed past the startled woman to throw open the front door. Meanwhile, Sergeant O'Connor rushed into the back of the small house. The chief heard his man shout, "Hey, Kelly."

The detectives then heard a loud thump and O'Connor shout, "Lay still, you."

The cops ran into the back bedroom to find O'Connor pointing his gun at a man lying on the bed. Chief Kelly could see the man had a bandaged

left arm strapped against his chest. Just past his head but within reach was an open nightstand drawer. Inside, a loaded .38.

"Who's he?" Kelly asked.

"I don't know," O'Connor answered.

Kelly shouted, "What's your name?"

No answer.

Kelly grabbed the man and began to shake him. "Can you not speak?" he shouted.

"Who is he?" O'Connor demanded of the woman.

"His name's Marty Colson," she answered.

"Where is Jerry?"

"I don't know," the woman responded.

O'Connor guarded the prisoner as the bureau men searched the home. Figuring it was now or never to escape, Colson leapt from the bed only to be knocked backward by O'Connor.

Colson was taken to police headquarters by ambulance. There, the police surgeon discovered Colson's injury was a gunshot wound to the shoulder.

It had been approximately forty-eight hours since the commission of San Diego's bloodiest crime, but clues were still coming in. Among them: a report of two men painting a car black at 3403 Thirty-First Street. Chief Kelly sped to the scene but found the house abandoned. Inside the home, detectives located a loaded .38 Smith & Wesson revolver. In the garage was an empty can of quick-drying black paint. The home had been rented by a Mr. and Mrs. R.K. Jamison. Neighbors reported "Mrs. Jamison" had red hair.

8:45 P.M.: KELLY AND Paul Hayes interviewed Mrs. Jerry Kearney. After an hour of meaningless conversation, Hayes went for the throat. Twirling the strand of red hair in his fingers, he demanded, "Mrs. Kearney. Who is the redheaded woman?"

Kearney at first looked startled, and then her eyes fell toward the floor. She muttered, "Jean Lee."

Kelly jumped to his feet and sprinted to the ID Bureau. He knew the name as well as his own. He also knew an associate of hers. Telegraphs were sent up the California coast and into Arizona. The dragnet was quickly growing.

Back in the interrogation room, Hayes continued his bracing. Jean Lee had brought Colson to the Kearney home on May 20. He'd been shot, she claimed, in a hijacking up the coast. She never mentioned the cash car robbery.

Detective Sergeant George Cooley and his police matron wife serve as book ends to Mrs. Jerry Kearney as the accomplice to murder is led to jail.

Hayes said, "Has Colson received any medical attention."

Kearney responded, "No."

Hayes asked, "Who is Lee Cochran?"

Kearney answered, "He's a friend of Jerry's. He runs a motorboat in Long Beach."

Hayes asked, "Did he come to the house on the twentieth?"

Kearney said, "Yes."

Hayes further questioned, "What else happened?"

Kearney answered, "I heard both Colson and Cochran tell my husband if he didn't help them things would be bad for him."

Kearney sobbed as she related how Cochran made her husband drive him to Long Beach. He left behind orders to care for Colson while they were away.

Despite her claims that Colson hadn't received medical attention, a canvassing of the neighborhood revealed a witness who had seen a doctor visit the home. A check of the license plate revealed the identity of the doctor, and Sergeant O'Connor soon learned he had treated Colson at home and at his office, where he removed a .38-caliber slug.

The wound was a promising lead. One of the guards, Nemesio Monroy, had been armed with a .38, and a shot had been heard coming from inside the Cadillac.

Walter Macy's examination of the sunglasses brought good news. Comparing the print lifted from the lens to an inked print card of Colson, he made a perfect match. Colson was now directly linked to the murder.

One day later, a store-by-store search of neighborhood paint suppliers brought further results. The paint can recovered from the garage on Thirty-First Street was sold to a man matching Colson's description. His fate was sealed when the store proprietor picked Colson from a mug book.

Despite the mounting evidence, the cops' prime suspect chose not to talk. Newspapers covering every move in the case labeled him "Silent Colson."

TUESDAY, MAY 24, 1927: That afternoon, the bureau was notified that Long Beach Police officers had arrested Jerry Kearney. The telegram went on to say LAPD officers had a line on Lee Cochran as well.

Detective Sergeant George Cooley and Deputy Sheriff Blake Mason were quickly dispatched north. Additional uniformed officers were provided as backup.

SDPD detectives soon located additional witnesses who recalled seeing two men, one identified as Colson, leaving a duplex at 3362 Grim Avenue. Both men carried handbags, and one carried a large, heavy burlap sack. Detectives learned that home had been rented by Joseph Renault on May 7, 1929.

A lack of instant communication was causing anxiety for Kelly and Hayes. They knew Cochran was uninjured and, facing the gallows for his crime, would shoot it out with police if cornered.

The LAPD search led the policemen to a flophouse hotel. After confirming Cochran probably was inside a second-story room, the men crept quietly to the door and tried the knob. It was locked. The largest policemen slammed their bodies into the door. As it splintered, Deputy Mason and Frank De War, chief deputy investigator for L.A. County, pointed their guns at Cochran, who was still in bed.

"Get those arms up, Lee," Mason snarled. "One move and I'll blast you."

Cochran desperately looked around the room for a chance. With an arsenal pointed directly at him, he wisely retorted, "All right, boys. I'll be good."

A loaded pistol was later found beneath Cochran's pillow, just inches from where his head had been seconds before the policemen shattered the door.

In 1929, this now trendy Grim Avenue duplex was the hideout of two of San Diego's most armed and dangerous killers.

SUNDAY, MAY 29, 1929: Five days after the bloody robbery, four suspects were behind bars. Only Jean Lee and her husband, Marcelle Dellan, a convict with a long criminal history who'd earlier been positively identified as R.K. Jamison, were still on the lam.

Meanwhile, Jerry Kearney was talking.

"I didn't know they'd killed the guards. I was told Colson was shot in a hijacking up the coast."

Kelly asked, "What about the doctor?"

Kearney responded, "They made me get him. They said it would be worse if I didn't. So I fetched my family doctor to help."

Kelly questioned, "Did you ever have a machine gun in your possession?"

Kearney answered, "No, but Cochran had a gunnysack and a case with him. We took it to the beach, hired a boat and then threw it all in the ocean beyond the breakwater."

Hayes said, "I want to know if that machine gun was used in this crime."

Kearney replied, "Cochran said the gun was used in the crime when I mentioned reading about all this in the paper."

The interview was interrupted with a tip: Marcelle Dellan was hiding on the Coronado Islands.

Visible from San Diego on a clear day, the four deserted islands are grouped off the northwest coast of the Mexican state of Baja California. Battered by wind and waves, they are today largely barren and uninhabited except for a small military detachment and a few lighthouse keepers. The islands lie fifteen miles south of the entrance to San Diego Bay but only eight miles from the Mexican mainland.

During U.S. Prohibition, a cove on South Coronado Island was frequently a meeting area for alcohol smugglers. Since it was the time before radar, and as foggy nights are common, the large number of boats frequently resulted in collisions.

So much traffic around the island led to the construction of a casino that flourished well into the Depression. Today, only the stone foundation remains, though the names "Smugglers Cove" and, more rarely, "Casino Cove" adorn modern maps.

Mason and O'Connor were sent into Mexico with orders to bring back Dellan. After crossing the border, the policemen managed to track down a

The San Diego County Jail housed some of San Diego's roughest types as they awaited justice. Standing on the southwest corner of Front and C Street, the five-story building was connected to the rear of the courthouse. It was demolished to make way for a new state-of-the-art court facility in 1962. In 2017, a new court was opened, and the 1962 courthouse was slated to be demolished.

Mexican Coast Guard cutter and then sail. Along the way, they encountered several large fishing boats loaded with rum. Not wanting to take prisoners for a violation of U.S. law, the coast guard turned their guns on the boats and demanded the captains toss their illegal cargo overboard.

A search of the islands did not locate Dellan.

Mason and O'Connor returned to SDPD headquarters three weeks later. The men were dirty, unshaven and smelled of salt water.

Kelly delivered the guns to Los Angeles for a ballistics analysis. As tests were being conducted, he met with fifty people who knew Colson. Concerned with a possible insanity plea, the chief of detectives personally interviewed each one about Colson's mental state.

Back in San Diego: despite no solid evidence of mental illness, Silent Colson communicated with the jailers only by drawing cartoons. He sketched an orange tree for a glass of juice and a cow for a drink of milk whenever he wanted something.

MONDAY, AUGUST 29, 1932: Justice came when Lee Cochran and Silent Colson were given life sentences. They pleaded guilty to avoid the rope—California's only form of capital punishment at the time. Jerry Kearney was handed a short jail sentence. His wife had been released due to lack of evidence. Marcelle Dellan was arrested months later but not charged when the detectives couldn't specifically link him to the case.

Colson proved to be a problem inmate at Folsom and received several stints in solitary confinement. In 1933, he fashioned odds and ends into a functional firearm and took a prison employee hostage. Unfortunately for Colson, the quick-witted hostage got the attention of other guards to surround Colson. As they closed in, Colson shouted, "I won't be taken alive!" He then put the gun to his head and pulled the trigger.

# FEMME FATALE

**S**aturday, January 9, 1932, 2:00 a.m.: 35 North Twenty-Seventh Street. John Cruppi tossed restlessly in his bed, annoyed at the disturbance next door.

"I wish that crowd next door would pipe down," he grunted to his roommate, Henry Hargraves.

Cruppi pulled the covers over his head and then the pillow. Neither drowned out the noise. Hargraves sat up and lit a cigarette to calm his nerves. He, too, was annoyed at the ruckus.

A door slammed on the other side of the narrow walkway that separated the small 1890s-era brown clapboard cottages. Hargraves was the first to peek out the window. Three men, one in a long coat, emerged from the rear of the neighboring bungalow. Cruppi joined his roommate to discreetly peer through the metal venetian blinds as the drama unfolded.

Moonlight illuminated the doorway of the one-bedroom domicile at 37 North Twenty-Seventh Street. Cruppi and Hargraves could see a woman with her hands on her hips as a man stood next to her. The pair were watching two men in a desperate struggle on the damp ground in front of them. Suddenly, the fight rolled right into the wall below the window the pair were peeking from. Cruppi and Hargraves recoiled to avoid being seen.

A male voice cried out, "Can I tell my wife goodbye?"

Then came, "Yes, go in and tell her goodbye for the last time."

Hargraves and Cruppi returned to the blinds just in time to see the three men and the woman return to the apartment and close the door.

"Well, I guess that ends that," Cruppi declared as he slid under his covers. There were no more sounds from the apartment for the rest of the night.

5:00 P.M.: A CALL came into SDPD headquarters requesting the police ambulance to 37 North Twenty-Seventh Street. Minutes later, the chauffeur and accompanying patrolman arrived to find Charles J. Crane, the manager of the apartments; Mrs. Anastasia Lambert, a neighbor; and a woman who introduced herself as Mrs. Willie Gallagher inside the small bungalow, which also housed a dead body.

The patrolman observed the body had fresh wounds on his face, including a gash over the right eye and another on the right temple. As soon as he verified he was dead, the patrolman found a phone and requested detectives.

6:00 P.M.: DETECTIVE SERGEANT Fred Lightner and Deputy Coroner David Gershon stood in the solo bedroom of 37 North Twenty-Seventh Street examining a corpse. Clad in a U.S. Navy uniform, including a regulation raincoat, the body was lying on its back on the double bed. Only his regulation white hat and shoes were missing. The body was partially covered from the waist down with the bedspread. On the other side of the bed was a pillow with the indented imprint of another person.

As the men carefully examined the body, Lightner suddenly realized he was being watched by a well-coiffed brunette standing in the doorway that divided the bedroom and the kitchen.

"Who turned off the gas?" Lightner demanded as he pointed toward a protruding wall outlet.

The woman stepped forward into the bedroom.

"No gas has been turned on since yesterday afternoon," she politely answered. "Why do you ask?"

"Because your husband's clothing reeks with the odor of illuminating gas."

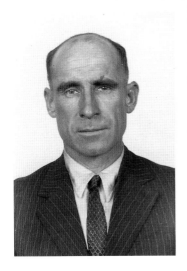

Detective Sergeant Fred E. "Jerry" Lightner. His sudden death on September 21, 1937, left the San Diego Police Department without one of its best homicide investigators.

Lightner turned to Gershon. "Don't you smell it, Dave?"

"It's plain enough to me," Gershon answered.

The coroner looked toward the woman and then motioned to a chair. "Why don't you sit down?" he offered.

The woman introduced herself as Martha.

"Why don't you tell us what happened?" Lightner asked.

Martha adjusted her bob cut hair with perfectly manicured fingernails. She looked toward the body on the bed and began to speak.

"Jim was brought home about one thirty this morning by two other sailors in uniform. They had a car. They just dumped him on the porch, rang the bell, said, 'Here's your husband' and then left."

"Do you know either of those two men?" Gershon asked.

"No, I don't," Martha answered. "Jim was terribly drunk, and he's abusive to me. So I dragged him into the bed around four thirty, and that's how you see him now."

"Then what happened?" Lightner pressed.

Martha shrugged.

"I managed to get his shoes off, then I went to bed. That's all. Jim put his arm around me, and I went to sleep. When I awakened, it was around three thirty this afternoon. I didn't want to disturb Jim, so I just got up, got dressed and fooled around the house for a bit. When I went to call on Jim, that's when I found him dead. I called Charlie Crane, the manager, and told him what happened. He called the police."

"So how do you account for his death?" Gershon asked.

"It must be the terrible liquor he drinks," she answered.

"And the gas wasn't turned on at any time?"

As Gershon asked the question, Lightner walked to the bed and sniffed the dead man's raincoat. The body reeked of gas. From where he was standing, Lightner could see through a window. Detective Sergeant George Agnew was outside anxiously trying to get his attention.

"Will you excuse me for a moment?" Lightner asked Gershon and the woman as he stepped outside. Agnew and Charlie Crane were standing in front of the cottage.

"There's something seriously wrong with that woman," Crane nervously reported to the two policemen. "She came here about a month ago with a sailor, and they rented that house. She said her name was Gallagher and the sailor was her husband."

"Go on," Agnew insisted as he began taking notes on his department-issued steno pad.

"But that dead man in the room is not Gallagher!"

"Come again?" Agnew asked in disbelief.

"It's not Gallagher! When I saw him on the bed, she told me his name is James W. Basham. What do you make of that?"

The policemen traded glances with each other. "We need to get to the bottom of this," they declared as they went back into the house.

Armed with the new information, Lightner confronted the woman.

"OK, spill the beans, lady," Lightner demanded. "Who's Gallagher?"

"I don't know. I've never used that name. My name is Martha Elizabeth Basham."

"Your landlord says different. So who was with you when you rented this house?"

"Just a friend."

"But you rented this place as Mrs. Gallagher. How do you account for that?"

"I can't because I've never used that name."

Lightner looked toward Agnew and Gershon. "Toss the house, will you?"

Lightner resumed his questioning but noted Basham kept shooting nervous glances toward Agnew and Gershon.

"Why would the landlord make up such a story about you?" Lightner demanded.

Basham shrugged her shoulders.

The search of the home revealed everything to be immaculate. The carpet-covered floors were spotless. Except for a broken magazine rack, the furniture was undisturbed. There was no sign of a struggle. The kitchen floor was also spotless, but a box under the sink roused suspicion.

"Did you clean house today?" Lightner asked Martha.

"No, I didn't. I haven't been feeling well lately, so I put off ironing. I'd intended to sweep the floor when Jim got up and left."

By now, Agnew and Gershon had returned to the room.

"So what about these cigarette butts, matches and an empty bottle we found under the sink?" Agnew asked.

Martha smiled. "Oh, that's just an accumulation of trash. I'm afraid I'm not a very good housekeeper."

"And what about this?" Agnew asked as he held up a bloodstained rag. "How do you explain this?"

Martha paled. "I used that to wipe the blood from Jim. You see, he had a fight with the two fellas that brought him home."

"So he was in a fight, eh?" Lightner replied.

"Oh yes!" Martha retorted. "That's what really woke me up."

Gershon continued searching the house as Martha once again insisted she had not turned on the gas heater. She did confess it was usually kept in the living room and she had dragged it into the bedroom; however, she remained steadfast she had never turned on the gas.

As Martha spoke to Agnew, Lightner rummaged the closet. Inside the coat pocket of a man's suit, Lightner found a registration card for an Oldsmobile roadster. The name on the registration card was William G. Durborow.

"Who does this suit belong to?" Lightner asked.

"To my brother, Edward Moore. He's in the navy and stationed on a tugboat at the naval yard."

"Who's Durborow?" Lightner sharply demanded.

"He's a friend of both Jim and I," Martha calmly answered.

"Do you know where he is now?" Lightner quickly responded.

Martha hesitated a moment and then answered, "No, I'm afraid not. He's also in the navy, so he could be anywhere."

The undertaker arrived and removed the body from the scene. That gave Agnew and Lightner a chance to more closely examine the bed. Under the pillow once propping up Jim's head they found a pint flask containing alcohol.

"Did he drink any of this when he came home?" Agnew asked.

"He took several shots, and he gave me one," Martha answered.

"What about this?" Lightner asked. He was holding a black USN button that matched one missing from Jim's coat.

"Any idea how this got across the room?"

Martha shook her head. "I don't know unless it was torn off as I was trying to get him in bed."

"Torn off?"

Martha picked up the insinuation and launched a counterattack. "Do you think I killed him?" she screamed.

"I don't know," Lightner fired back. "But things aren't adding up here."

Lightner looked toward Agnew. "Take her downtown and book her. I'm going to see what I can find in the neighborhood."

Martha was handcuffed, taken downtown and remanded to the police matron, who booked her in the women's jail.

Meanwhile, Lightner questioned neighbor Anastasia Lambert. He learned the dead man was not a resident of the house where he was found, and another sailor known as Gallagher would frequently come around.

"Did this Gallagher have a car?" Lightner asked.

"Yes, but I'll be danged if I can recall what kind," Lambert answered.

"What else?" Lightner asked.

"Mrs. Basham told me she and her husband were separating and that he was a member of the navy shore police."

"Did you see her today? And if so, what time?"

"I saw her around three thirty. I was hanging some clothes on the line when she came up and told me something was wrong with Jim. I didn't know who Jim was. She called the man who lived there Willie, so I ran over and told Mr. Kane. When we went into the house, that's when we discovered Jim was dead."

"How did she act? Was she excited when she summoned you?"

"Not at all," Lambert replied. "She used the same tone of voice with me as she would if she were inviting me to the store."

"Were you home last night, Mrs. Lambert? Did you see or hear anything?"

Lambert grimaced. "I'm sorry, I can't be of help there. I spent the night with a friend."

Lightner was disappointed. The Lambert cottage was almost directly to the rear of the death house, so she would have been perfectly positioned to witness something.

No other residents of the courtyard apartments were home, so Lightner visited a service station on the corner of Evans and Imperial Avenue. The station was less than a block from the murder. The proprietor was Charles P. Carrol. After identifying himself, Lightner sat down with Carrol and asked if he'd seen or heard anything out of the ordinary on the night in question. Carrol had nothing to add, but as the men were speaking, a customer named E.B. Gossett came into the station and overheard the conversation.

"Are you talking about the place on the corner?" Gossett asked as he pointed toward the death house.

"Yes," Lightner answered. "Did you see something?"

"Well, I go to work every morning at about 6:45. This morning as I passed by, I saw two sailors walk out of the house and walk south on Twenty-Seventh Street."

"Did you happen to see where they went?" Lightner pumped.

"No, I didn't watch them that closely."

"Are you sure it's them?"

"Yes."

"Can you describe these men to me?"

"I'm afraid I can't. They were sailors. That's about all I can offer."

Lightner returned to police headquarters frustrated. In discussing the case with Agnew, both men agreed things were off, but they didn't have

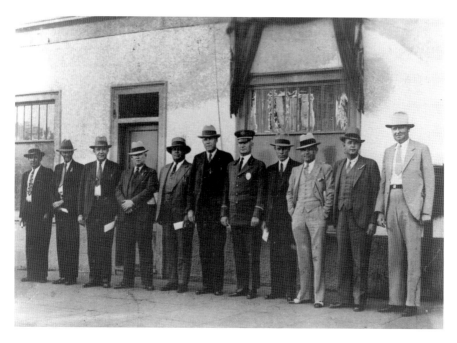

Most of the bureau, 1933. *Left to right*: Fred Lightner, John Beaty, unknown, Paul Slattery, John Cloud, Omer McCollum, Chief Robert Newsom, John Kane, William O'Connor, George Agnew and unknown.

enough to pinpoint exactly what. Was Martha covering for someone, or was she protecting herself? Who was Durborow? Both agreed they would learn more from the pending autopsy.

Meanwhile, Lightner visited the Shore Police, who happened to be housed in SDPD headquarters. Thanks to their radio attached to the Eleventh Naval District Headquarters, within half an hour Coxswain William Durborow was in custody.

Lightner was briefing his superior, Harry Kelly, on the case when two sailors, a tall officer and an enlisted man, walked in the homicide office.

"This is C.M. Lewandowski from the USS *Holland*," the tall officer reported as he motioned toward his companion. "He just reported to me that he has some information on the Basham case."

Lightner and Kelly discovered Lewandowski was a close friend of the dead man. Both were stationed on the *Holland*. Both were assigned to Shore Police duties. They'd been relieved of duty on January 8 shortly after midnight. According to Lewandowski, Basham was living in a hotel during his shore duty time as he (Lewandowski) resided on the ship. Lewandowski said after

he and Basham were relieved, they walked to a café for a late-night meal. While eating, the conversation drifted into Basham's marital problems. According to Lewandowski, Basham wanted to visit his wife and talk to her about a divorce. He asked Lewandowski to accompany him. A taxi delivered them to the Twenty-Seventh Street house around 1:30 a.m.

"I waited in the car as Jim went in," Lewandowski said. "I finally got tired of waiting and went up to the door. Jim answered, and he was pretty pie-eyed. There was another fellow in the house who Jim introduced as Willie. Later, we went into another room, and I saw a dame lying in bed."

"That dame was Mrs. Basham," Lightner interjected.

"Well, whoever she was, Willie and Jim were arguing about her. Then they had their dukes up and started throwing punches because Basham was trying to get Willie out of the house. I managed to get them separated, and we all went into the kitchen to have a drink and cool off."

"Did Mrs. Basham drink too?" Kelly asked.

"She didn't get a chance to. Jim and Willie started throwing blows again, and Jim took one in the nose. I separated them and even made them shake hands, but it didn't last. Pretty soon they started up again, only this time it spilled outside, and Jim got cut on his eye."

"Was this guy Willie also very drunk?" Lightner asked.

"No."

"And what was Mrs. Basham doing?" Kelly asked.

"The broad went out and watched the fight and then went and got back in bed. That's when I saw Jim crawl into the bedroom on his hands and knees crying and begging her to take him back. That's when I stepped into the other room."

"Did Jim's face get cut from those bouts?" Lightner asked.

"Yes. He was bleeding pretty good, so I went and got a rag from the bathroom and wiped him up."

"You did?" Lightner interrupted. "Are you sure of that? It wasn't Mrs. Basham who wiped him up?"

"Of course I'm sure," Lewandowski fired back.

Lightner continued to press. "What did you do with the cloth?"

"I threw it on the floor. Not that it mattered. You couldn't make that joint dirtier if you tried. There were cigarette butts and burned matches all over the floor. The place was a real pigpen."

Lightner snapped his fingers. "So the woman was lying about the house!" he exclaimed. "I knew it. She's a good actress and apparently a pretty skilled stage manager too. That house was immaculate when we saw it."

"Well it was a dump when I was there," Lewandowski fired back.

"Where was Basham when you left?" Lightner asked.

"On the couch in the living room."

"What kind of shape was he in?" Kelly asked.

"Other than the cuts on the face, he was fine. He even walked out to the curb and talked to me and Willie as we were about to drive off in Willie's car. He made arrangements to meet him this afternoon."

"What time did you leave?" Lightner asked.

"It was shortly before 7:00 a.m."

William "Willie" Durborow was next to be interrogated. He corroborated everything Lewandowski said and confessed to being the mystery man named Gallagher who had been living at the house where the dead man was found.

Durborow added, "Around 2:30 p.m. on January 8 we were having supper in the kitchen when Jim walked in the house. We offered him a cup of coffee, and he sat down, but when we started talking about his divorce, he began accusing me of stealing away the best thing he'd ever had."

"What'd he mean by that?" Kelly asked.

"His wife, I suppose."

"What happened then?"

"He left. I didn't see him again until around one thirty the next morning. He came back to the house, and we got into a fight. Then the other guy named Ski [Lewandowski] showed up. I didn't want any part of it, and I guess Ski didn't either, because we left in my car with Jim standing at the curb."

Kelly buzzed the police matron. "This is Captain Kelly," he said into the intercom. "Go to the jail and get Mrs. Basham and bring her to homicide. We have some questions for her."

Ten minutes later, Martha was sitting in a metal chair, staring down Kelly and Lightner.

"It seems you weren't completely honest with us," Lightner accused. "We just spoke to Willie and Ski about the night Jim died."

Martha swallowed hard.

"So I fibbed about a few things. I didn't want my personal business splashed all over. The rest of what I said stands, and that's all you're going to get from me," she growled.

SUNDAY, JANUARY 10, 1932, 9:00 a.m.: Sergeant Lightner and Detective Ed Dieckmann returned to the Twenty-Seventh Street apartments to knock on doors.

The first to be interviewed were Mr. and Mrs. Fred Dukes. The couple lived in the complex and reported that late on the eighth or in the early morning hours of the ninth they were awakened by loud talking coming from the house occupied by the man they knew as Gallagher. The couple agreed there were a number of different voices coming from the house. Mr. Dukes stated he clearly heard a man ask, "Can I see my wife?" but couldn't distinguish what else was said.

The detectives struck gold at their next stop. Just thirteen feet from the Basham apartment was the residence of John Cruppi and Henry Hargraves. Both men began their interview by stating they were furious to be woken up by the loud noise. Cruppi identified one of the fighters as Willie and stated he had seen him at the cottage many times. Cruppi said the other man, dressed in the raincoat, was an infrequent visitor and added he'd never seen them together before.

On a second search of the house, Dieckmann located several insurance policies on James W. Basham with Mrs. Basham as the beneficiary. "I may have found our motive," Dieckmann declared as he showed the policies to Lightner.

A follow-up by Detective Sergeant William O'Connor revealed neither Willie nor Lewandowski had left the ship since being interviewed by homicide. Both men had exemplary service records, and everyone contacted had nothing but praise for them.

WEDNESDAY, JANUARY 13, 1932: The autopsy concluded James Basham died of carbon monoxide poisoning such as contained in illuminating gas. His facial wounds were of no relevance to his demise. Martha was brought back to the homicide office for a stiff bracing.

Kelly began. "Mrs. Basham. The autopsy shows your husband died of gas poisoning. Just like we expected. What do you have to say about that?" he shouted.

Martha leapt from her chair. "They lie, they lie," she screamed hysterically. "How can they say that? If he died that way, I would have died too, as I was in bed with him. Stop nagging me about this!"

Kelly slammed his hand on his desk to reassert himself. "Then what?" he implored. "Did he commit suicide?"

"No, no, no," Martha shouted back. "He died of bad liquor, I tell you. That's what killed him. There was no gas!"

SATURDAY, JANUARY 16, 1932: An inquest was convened. Martha took the stand and repeated her story that her husband died of bad liquor. This time, she also claimed Jim got out of bed and hit her and then crawled back into bed, put his arm around her and went back to sleep. Martha insisted Jim was in bed when the other men left the house.

Dieckmann was next to testify. He told the inquest he found a note in the pocket of Jim's raincoat: "I Martha E. Basham will not ask anything of James W. Basham. (Signed) Mrs. J.W. Basham."

Despite the insurance policies and a motive, the inquest jury returned a verdict of death by asphyxia; however, they could not determine who, if anyone, was responsible for the death.

Martha Basham was released from custody.

FRIDAY, MARCH 25, 1932: William Gallagher Durborow and Martha Basham were married. By that time, Martha's drinking was becoming out of control, and she had been arrested a month earlier for being drunk in public and smashing a glass bottle on a sidewalk.

Friends were starting to talk. One came forward and told Sergeant Lightner that Martha confessed to her that another person had been in the home after Willie and Lewandowski left. That turned out not to be true.

SATURDAY, JUNE 18, 1932: Another neighbor reported to Lightner that Martha was drunk and confessed to killing Jim. That tip led the district attorney to send two investigators, Thomas Frost and Gus Stafstrom, to visit Martha at her new home at 1026 South Thirty-First Street first thing Monday morning.

After knocking on the door, a woman's voice shouted from behind the closed entry. "What do you want?" she demanded.

"Open the door. We'd like to talk to you," Frost answered.

"About what?"

"Mr. Holt, one of our deputy DAs, would like you to come to his office."

"Do you have a warrant?" Martha growled.

"No."

"Then get off my property before I have you arrested for trespassing."

TUESDAY, JUNE 21, 1932, 9:00 a.m.: Martha appeared at the DA's office with her attorney, John Fitzgerald. DA Thomas Whelan questioned her for more

than two hours, but the entire event was a continuum of lies. On the advice of Fitzgerald, she finally took the Fifth and stopped speaking.

As the pair stood to leave, they were presented with a warrant for her arrest. The charge was murder. Martha was handcuffed and booked back into jail.

SUNDAY, AUGUST 21, 1932: Martha E. Durborow walked out of court a free woman when a hung jury couldn't arrive at a verdict on the first-degree murder charge.

Undeterred, DA Whelan filed charges again, and she was rearrested and booked.

WEDNESDAY, SEPTEMBER 14, 1932: Martha's second trial opened to an eight-woman, four-man jury. Her attorney, Edgar Langford, tried to push forth suicide as the cause of death. The DA countered by demonstrating it would be impossible for Jim Basham to connect the gas, turn it off and then disconnect the wall valve after it had killed him.

WEDNESDAY, SEPTEMBER 21, 1932: The jury returned a unanimous verdict of guilty of first-degree murder.

WEDNESDAY, OCTOBER 5, 1932: Claiming to have discovered new evidence, Attorney Langford filed a motion for a new trial. It was denied. Martha was sentenced to life in prison at San Quentin. After sentencing, Judge Mundo asked Martha what she planned to do with a life behind bars.

"I like to read a lot," Martha replied.

"Anything in particular?"

"I'm very fond of true detective stories," Martha answered. "Although I probably won't be anymore."

TUESDAY, APRIL 11, 1933: Martha's appeal was denied by the District Court of Appeal.

THURSDAY, APRIL 27, 1933: The California Supreme Court also denied Martha's appeal.

# THE NIGHT STALKER

**M**onday, August 1, 1932, shortly after 2:00 a.m.: It was a balmy morning when a prowler happened upon the open bedroom window of a U.S. Marine Corps captain and his wife peacefully sleeping in their Spanish Hacienda–style home in Mission Hills. With the shrubs as cover, the intruder lingered below the window for several minutes listening. The couple's breathing pattern indicated they were in deep sleep.

Silently removing the screen, the intruder used his flashlight to scan the bedroom. When the roving beam of light went across the eyes of the captain, the marine half consciously threw a protective arm across his face. Suddenly, it occurred to him there was no good reason for a light to be in his room. The captain sat straight up in bed to find an armed intruder standing at his window.

"Get out of that bed," the gloved prowler demanded. "And come over here."

Awakened by the sudden movement of her husband, the wife propped herself up in a groggy haze.

"What's the matter?"

The intruder shined his light into the woman's eyes, blinding her.

"Shut up or I'll blast the both of you!" he menacingly barked.

The woman fell back, resigned, and then began sobbing.

The marine shot a quick glance toward his chest of drawers. He was within a split-second's reach of his .45 government-issued pistol. The brazen robber sensed his thoughts.

"Don't even think about it," the prowler commanded. "Now throw your trousers over here, and no funny tricks out of either of you!"

Concerned for the safety of his wife, the marine docilely wadded up his pants and threw them out the window.

"Now let's see your hands, lady," the robber menacingly demanded.

As she lifted her hands above the bed, the light caught the brilliance of her diamond ring.

"Toss that over here!"

The bandit scooped up the ring and backed away from the window. Then the light blinked out and running footsteps sounded through the night.

The marine rushed for his pistol and then dove out the window in hot pursuit. Unable to see the robber, the marine fired several shots into the shrubs of a deep canyon but had no idea if he hit his target. Concerned about suddenly leaving his wife alone, the captain quickly turned and ran back home.

Moments later, the voice of Vernon "Tommy" Thompson, SDPD's first police radio announcer, cut the night air: "Calling cars 17, 18 and 19. Converge on Arden Way and adjacent streets. There's been a holdup. Stop all cars and men and investigate."

Uniformed policemen quickly converged on the neighborhood. But even with most of the night shift at the scene, the efforts were in vain; neither victim could describe the robber, and detectives couldn't locate fingerprints.

Alone, in a tiny shack in Balboa Park, SDPD's first radio dispatcher, Vernon "Tommy" Thompson, played a vital part in chasing the Night Stalker.

The only physical evidence was a set of moccasin prints in the soil below the window. Unlike a shoe with a wear pattern, the moccasin with its soft leather sole would be useless for comparison even if the suspect was caught wearing them.

As the officers were still investigating the crime, the prowler struck again just two miles away. Policemen were on scene within minutes; however, as with the previous crime, the suspect was long gone.

For weeks, the Night Stalker struck with maddening regularity. Often there were as many as four cases in one night. In complete contempt for the blue suits trying to nab him, the bandit continued to launch his attacks even as officers sought him for other crimes a short distance away.

As the cases stacked up, so did the clues. When the marauder didn't completely blind his victim, several victims got a look at him. Each description was the same: he wore a hat pulled down to his brows and a mask shielding the lower part of his face.

To further complicate matters, the Night Stalker changed his mode of operation. In his first cases, he opened a window and robbed people inside the home. Later, several victims woke to find the ghostly prowler standing over them with a gun in one hand and the flashlight in the other. In each case, the robber demanded money, and he rarely took jewelry unless it was a ring or a stickpin found on the dresser.

Detectives later discovered a number of victims slept through the heist. In those cases, the victims woke up to find their pockets turned inside out or their clothes on the front porch.

One woman stated she awoke to see a shadowy figure at the foot of her bed.

"Get out of here, you thief!" the panicked woman shouted.

The intruder snarled and then flashed the light into her face.

"Shut your trap," he barked as he backed out the window.

The startled cry woke a neighbor, who stepped outside. With a gun in hand, the neighbor spied the robber running down the street.

"Stop or I'll shoot!" the neighbor shouted.

The bandit whirled around and pointed his own gun. "So will I!" he spouted back.

The neighborhood reverberated with loud pops as the men traded gunfire in the streets. Neither man was struck. Then, like in every case previous, the Night Stalker simply vanished.

The crime spree was bad enough, but up until the gunfight, he'd been an annoyance at best. Now that he had demonstrated his willingness to use deadly force, the case landed squarely on the desk of Chief of Police Robert Newsom. Although new to the top position, Newsom was no stranger to the SDPD. Having come up through the ranks, the sixteen-year veteran knew the bureau well enough to assign the series to the commander of the Robbery Unit, Detective Lieutenant Jasper L. Berg.

The lieutenant quickly reassigned most of the day shift to night hours. Borrowing the scant number of cars equipped with one-way radios, detectives could gain a bit of an edge in responding to the calls if they could hear them when they came in.

Berg next directed a teletype to be sent to Sacramento requesting the Department of Justice provide information on known criminals with the

same MO as the Night Stalker. The response that came back was four. Two had airtight alibis; they were behind bars in San Quentin. The other two had vanished. A nationwide search began.

As the cases stacked up, so did evidence: fingerprint smudges in one case, moccasin prints in another. Detectives kept track of every little clue so when a possible was collared a case could be made.

Shotgun squads, radio patrol prowl cars and armed citizens all kept a close watch on homes in the Mission Hills district. In spite of the precautions, the daring bandit continued with his raids.

Then, as suddenly as the spree began, it ended. For ten days, the city was quiet as the Night Stalker ceased his raids. Citizens began to relax. Police eased back on saturation patrols.

TUESDAY, APRIL 4, 1933: The Night Stalker struck four locations in one night, including one robbery in which he held a woman at gunpoint as marked police cars were half a block away investigating his last hit.

Worse than his frequency of cases was the increase in his bravado. Not only was the stalker unafraid to hit in areas saturated by police, but he seemed to relish it.

The Night Stalker also began to set elaborate traps to thwart potential vigilantes. In one case, the bandit placed old crates along the premises of a house. When the irate homeowner dove out the window to give chase, he crashed into the crates and fell to the ground. To add insult to injury, the Night Stalker was heard laughing maniacally as he vanished into the night.

By now, citizens were so desperate to capture the bold intruder that they began to stalk one another. Several hobo camps were raided by average citizens who administered beatings and death threats to those who didn't leave town immediately.

The SDPD was more calculating. Armed with the names of two known "bedroom men" supplied by the Department of Justice, bureau men eventually located the convicts. One was in jail on the East Coast. The other had an airtight alibi in Texas.

Meanwhile, with maps strewn across his desk, Lieutenant Berg was finally starting to make some progress. By analyzing the time, date and location of each job, Berg noticed a single commonality: the Night Stalker always pulled his final job in the northwestern section of San Diego's residential area. With a wide swath of undeveloped Mission Valley farmland dividing the southern end of the city from La Jolla and

Del Mar, Berg rolled the dice that the suspect lived somewhere near his last caper. By changing the areas of patrols, the department witnessed a reduction in the assaults.

The Night Stalker apparently also noticed the change. He switched his MO and began hitting the previously untouched coastal neighborhoods of Pacific Beach and La Jolla. Berg had already anticipated the move and saturated the area with uniformed officers in cars and on motorcycles and horseback.

MONDAY, OCTOBER 2, 1933: P.R. Robles was in the back room of his tamale factory at 4620 Taylor Street, sleeping off a hard day, when suddenly his homemade alarm jolted him out of bed. Silently pulling on his trousers, Robles grabbed his .38 revolver and a flashlight. He silently crept onto the main room of his modest factory. From where he was standing, he could see a shadowy figure on the screen porch trying to get inside. Leveling his gun toward the shadow, Robles shouted, "Come out of there, I've got you covered!"

The intruder rose up, looked around and then ducked back down. Aiming toward the shadow, Robles fired one shot. A loud crash was heard. The figure popped up from his hiding place in a full sprint.

"Halt!" Robles commanded. "Or I'll fire again."

The figure quickened his pace in the opposite direction.

Robles fired twice more as the fleeing phantom vanished around the building.

A short distance away, in front of 2944 Whitman Street, a young couple was startled by the sound of rapid gunfire. S.R. Hibbard was returning from the theatre with his date, Edna Bennett, when he heard what he thought were loud backfires. Glancing through the back window of his car, Hibbard said the moonlight was faint and he saw nothing. Then came two more sharp cracks. This time, Hibbard saw a flash of orange flame and could hear footsteps running toward him.

A man suddenly appeared out of the darkness and fell into the side of Hibbard's car. As Hibbard got out to see what had happened, he saw the man was holding a gun. Before he could say a word, the man got to his feet and continued running.

Hibbard bolted toward his girlfriend's house to phone police. As he ran toward the residence, the cool night air was pierced by the wailing of mechanical sirens responding to the tamale factory alarm.

Hibbard quickly told officers what he had seen and then joined them in the search for the fleeing bandit. With their guns unholstered and at their sides, policemen quickly fanned out across the neighborhood.

Two blocks from where Hibbard first saw the running man, a loud cry emanated. Sergeant Jump was standing over a man's body sprawled next to a car on a residential street. Other policemen ran to assist. They could see the wounds were grave. As the man lay dying, a policeman ran to find a telephone while the others grilled the man for his name. He gave nothing before he died.

The deceased was attired in dark clothing, including a jacket and brown sneakers. The big shock came when the corpse was undressed at the morgue. He was wearing the finest silk panties! Deputy Coroner Cy Hebert searched the man's pants and found the .32 pistol the Night Stalker used to threaten his victims. In his pants pockets were two diamond rings, thirty-five dollars in gold and bills, two passkeys and a curiously shaped length of stiff wire.

Lloyd Miers of the ID Bureau met the coroner at the mortuary the morning after the shooting. After dabbing India ink on the tips of the dead man's fingers, the men carefully transferred the dead man's fingerprints onto a white paper card.

Back at headquarters, with his eye pressed to a microscope, Miers quickly classified the print pattern of arches, ridges and whorls, into the Henry Code format most police agencies still use to document the patterns of friction ridge skin of the fingertips. Once it was categorized, Miers walked to the

By the time the Night Stalker unceremoniously died in the street, he'd terrorized San Diego for most of 1933. A bullet from a factory worker ended his spree.

far end of the room to an array of filing cabinets bursting with more than a quarter million arrest reports, photos and inked print cards of pimps, jailbirds, degenerates and scofflaws.

Like a librarian using the Dewey Decimal System to find a single book in a cavern of writings, Miers looked carefully at the labels on the front of each drawer. Finally, he found the one nearest the dead man's code. Within a few minutes, he had plucked a card from the drawer and handed it to Lieutenant Berg.

"This is your man," Miers declared. "His name is Herschel Lafayette Combs. He's served time at San Quentin and Folsom. He was most recently paroled in 1929 after serving time for a burg job."

Across town at the morgue, other bureau men were holding an open house for victims, the press and the plain curious. Dozens of Night Stalker victims shuffled past the corpse. Most were able to make a positive ID.

Detectives finally located Combs's residence, a modest home near what is now Bay Ho. Berg had been searching right in the part of town where the Night Stalker lived! Detectives tossed his house and located every bit of the stolen loot.

Now that they knew who he was and where he lived, the next question was how did he pick his targets? Detectives learned Combs was a painter by trade. Working for one of San Diego's largest contractors, Combs estimated paint jobs on a number of exclusive homes, thus casing many of them for future raids.

The case was marked as closed but the Robbery Bureau lieutenant was still left with one thought: why was the Night Stalker trying to burglarize the tamale factory? As cautiously as he cased all of his prior targets, why was he so careless in the one that proved fatal? He would have known there was no money, jewelry or undergarments inside the factory. Just what was he after?

Berg and several officers met Robles at the tamale factory for an exhaustive search. After carefully scouring the premises, the men finally hit pay dirt: lying on the ground outside the window through which Combs escaped was a gunnysack. As he knelt down to open it, Berg silently wondered what he'd find inside. As he opened the sack, its contents fell to the ground, leaving the lieutenant dumbfounded. For the objects that winked back up at him like grim symbols of an ironic fate were bottles—ten bottles of beer, to be exact. For this, Southern California's first Night Stalker gambled his life and lost.

# A DEATH WISH

**T**uesday, March 7, 1933, 11:05 a.m.: Cortland Hotel, 725 Fourth Avenue, room 46. Detective Sergeants Hugh Rochefort and Ed Dieckmann followed the hotel manager, J.A. Wooste, into a death scene. On the floor lay the body of a man, covered from head to toe with a white bedspread. One sock-clad foot was exposed.

The bed was in disordered condition, as though the body had been dragged from it and gravity forced the bed clothing with it. A pair of men's pants was wadded up and discarded on the far side of the room.

The bureau men pulled back the bedspread. The dead man's face was swollen and discolored. As his tongue protruded from between his clenched teeth, a faint froth defined his lips. Around his neck was a broad leather belt cinched tight. Both wrists were deeply slashed. Between the left arm and the body was a broken pint whiskey flask, the ragged edge covered in blood.

Dieckmann knelt down to check the body. The man was still warm. As expected, there was no pulse.

Fifteen minutes earlier, Dieckmann had been at police headquarters taking a missing person report from a distraught mother missing her child. He spied Rochefort running toward him.

"Ed. There's a dead man at the Cortland," Rochefort exclaimed. "Get a car. I'll go with you."

The hotel was several blocks from headquarters. The men arrived within minutes of the call. They met Wooste in the lobby.

"So what exactly happened?" Dieckmann inquired.

Doggedly persistent, Ed Dieckmann was legendary for long hours, and there were times when he stayed on duty for weeks in order to crack a case.

"I knocked on the door of room 46 earlier but didn't get an answer," Wooste said. "So I went and got my pass key. When I opened the door, I saw the dead guy, and then I called you cops."

"Do you know who the dead man is?" Rochefort asked.

"No," Wooste answered as he looked through the hotel log book. "They came in around one o'clock this morning and signed in as Clark Gable and USS *Nelson*."

Rochefort grabbed the book.

"Who was working and allowed them to sign in like that?" the sergeant demanded.

"Joe Knight, my clerk," Wooste meekly answered.

"There's only one person in that room right now," Dieckmann said. "Did you see the other one leave?"

"No. But I heard someone leave just a few minutes before I discovered the body. I guess it was that sailor."

"Sailor!" Rochefort exclaimed. "Did you see that man?"

"No. Joe told me about them when I relieved him from his shift this morning."

"Where's Joe now?" Rochefort asked. "Does he have a room in this hotel?"

"Come this way," Wooste said as he led the men up the stairs to the second floor.

Pointing to a door on the far side of the hall, Wooste said, "He's in there, but he will be hard to wake up. He just went to bed a little while ago."

"You never mind that," Rochefort declared as he delivered a series of hard-pounding cop knocks on the wooden door. "I'll roust him all right."

Moments later, Knight was rubbing sleep from his eyes. He told the policemen the dead man and his companion came into the hotel around 1:00 a.m. The deceased registered while the sailor paid for the room. They'd both been drinking heavily but left a wakeup call for 6:00 a.m. Knight said about ten minutes later, the young civilian passed through the lobby and walked outside. He returned a half hour later alone. According to Knight, the sailor never left the room. At 6:00 a.m., Knight went to the room and knocked on the door, but there was no answer. Knight tried the door. It was unlocked. Knight said he peeked inside and saw the sailor alone and asleep. Knight said he shook the man to wake him and then walked out, leaving the table lamp burning. Knight said he didn't see any sign of the civilian's clothing in the room. Knight said he then went and woke up Wooste and went to bed.

The three men returned to room 46.

As Rochefort and Knight stood by, Dieckmann carefully examined the evidence. He began with a pillow slip on the bed. Noting the pillow was on the floor, Dieckmann found slivers of broken glass inside the slip. The shards matched a broken flask nearby.

On the bedspread that covered the body, Dieckmann noted a discolored area of blood and mucus, as though the spread had been used to wipe the man's face. Under the neck was a tightly folded towel, folded lengthwise. A pair of tan oxford shoes was located under the bed. On the floor were numerous cigarette butts. On the dresser was a water glass containing whiskey.

"Did you ever see that sailor before tonight?" Dieckmann asked Knight.

"No, sir. He's a stranger to me, nor do I know the kid he came in with. I wonder if they left the key behind. I'll go to the desk and look," Knight said as he left the room.

11:25 A.M.: DEPUTY CORONER David Gershon, a police photographer and several uniformed policemen were now in the room. A search was made of the body. No ID was located, and the corpse bore no unusual birthmarks or tattoos. The only thing inside the discarded pants was a room key to another hotel.

The men regrouped in the lobby. As they were leaving, the desk clerk shouted, "I have a call for one of you detectives."

Dieckmann took it. It was the desk lieutenant at headquarters.

"There's a man at Harvey's Lunch Counter at 216 Broadway claiming he killed a man at the Cortland. Officer Connors is on the way over there. You men better get over there too."

Dieckmann threw the phone back across the counter and shouted to his partner, "Come on, Hugh. We have to go."

The men raced to their car, fired it up and sped the five blocks to the restaurant. Motorcycle Officer Connors had already arrived and arrested the man and had the police chauffer deliver him to headquarters.

Dieckmann and Rochefort arrived back at headquarters to find a young, drunk radioman third class named Henry Francis Hoffman being booked. Dieckmann interrupted the booking and instructed his partner to get the department stenographer to meet him at their car.

On the short drive back to the Cortland Hotel, Hoffman offered up that he was stationed at the destroyer base. He didn't appear nervous and even refused a cigarette from Rochefort.

The men reached the hotel and immediately went to room 46. The photographer had snapped his last photograph when the bureau men escorted their prisoner and Knight through the door. Knight winced. Even with the corpse in plain view, Hoffman didn't bat an eye.

Rochefort quickly motioned for the stenographer to begin taking notes.

Pointing to Hoffman, Dieckmann asked Knight, "Is this the man who occupied this room last night?"

Knight nodded. "Yes."

Dieckmann pointed to the body. "And he came in with this man?"

"Yes."

Hoffman stared at the floor as Dieckmann questioned Knight.

Rochefort noted Knight was visibly shaken by the questioning.

Dieckmann turned toward Hoffman. "Do you know this lad?" he demanded as he pointed to the corpse.

"No. I've never seen him before," Hoffman replied sarcastically.

Dieckmann continued, "Did you come to the hotel last night with him?"

Hoffman looked directly at Knight. The clerk was so unnerved that he was standing almost directly behind Rochefort.

"Of course I did," Hoffman shouted. "You just heard him say that!"

"Did you kill him?" Dieckmann fired back.

Hoffman took off his hat. "I wish I hadn't, but yes, I killed him."

"Why?" Dieckmann asked.

"I don't need a reason, do I?" Hoffman growled rhetorically.

"Not now anyway," Rochefort fired back as he shoved Hoffman backward into a chair.

Hoffman took a deep breath. "I can't really say why I did it. We'd been drinking earlier that night, but I wasn't drunk when I woke up that morning. I saw him sleeping there so peacefully, and I managed to get his belt off his pants and I put it around his neck. Then he woke up and began to struggle. He knocked the belt away twice before I finally got it tight around his neck. He struggled, I don't know why, and I dragged him to the floor."

"How'd his wrists get cut?" Dieckmann asked.

"I slashed them with a bottle after I choked him," Hoffman answered. "I put the bottle in the pillow slip and broke it on the floor. Then I used the sharp edge, but he didn't bleed much."

"Can you help us with who the lad is?" Rochefort asked.

"Sorry. I have no idea," Hoffman answered.

Hoffman was returned to police headquarters within the hour and booked for murder. As he was being booked, the jailor found a room key to another hotel. The key was registered to a man named J.P. McDonald Jr.

Investigators would later discover no one in town knew of a J.P. McDonald Jr. The most they could determine is he'd been in San Diego for approximately four months but hailed from parts unknown. Law enforcement teletypes with McDonald's photos and fingerprints were sent to every large police agency in the United States. To this day, no one has ever identified him.

The coroner determined McDonald died from strangulation and that he received several blows to his head. The cut wrists were postmortem and incidental.

10:00 P.M.: DIECKMANN REQUESTED the jailor release Hoffman to his custody. After walking Hoffman back to the Detective Bureau, Dieckmann locked the door and sat Hoffman in a seat across from his desk.

"OK. I want to know the truth," Dieckmann demanded. "No more games. I want to know why you did it."

Hoffman was stubborn at first and repeated his previous answers. He told Dieckmann he tried to strangle McDonald with the folded towel but discovered it wasn't long enough, so he used the belt.

After two hours of prodding, Hoffman finally cracked. Sobbing, he confessed that he'd been sent back from Pearl Harbor to face a bad conduct discharge over his drinking. When he arrived in San Diego, his superiors told him he'd be given a second chance to make good. Hoffman claimed if he obeyed the terms of his probation, he could receive a good conduct discharge but not allowed to reenlist.

"On March 6, I submitted a letter to Washington requesting I be allowed to extend my enlistment," Hoffman said. "The letter was passed through every officer here also, and it was then I learned that they would have to recommend denial because of my past record."

The five-thousand-square-foot clapboard building and connecting jail at 700 Second Avenue served as SDPD headquarters and housed the bureau from 1911 to 1939. Rent was $150 per month.

"Continue," Dieckmann insisted.

"Well, that was just kicking me when I was down. I came ashore yesterday and was thinking about it all the time. How my life was over. So I started drinking. A lot. That's when I met this kid. When I woke up this morning, I still had the affair on my mind, so I made up my mind to get myself into a place where I didn't have to worry about the future. That's when I decided to kill that fellow then give myself up. That's why I want to hang!"

Dieckmann was stunned. "Did this lad do anything to you to deserve that?"

"No," Hoffman answered. "I have no personal feelings against him at all. It just happened that he was there. It could have been anyone, to be honest."

Hoffman looked around the dimly lit bureau office and then at Dieckmann. "I'm sure I could have escaped. I could escape now."

Dieckmann discreetly reached for his revolver.

"Relax," Hoffman insisted. "I told you, I want to die for this. That's why I called the police twice. The first time the officer didn't find me, so I called back."

Dieckmann would later find Hoffman's story checked out. The morning of the murder, Hoffman stepped into a dry goods store near the Cortland Hotel and informed the proprietor he had just killed someone. Smelling alcohol on his breath, the storekeeper didn't take the confession seriously and suggested Hoffman go somewhere and "sleep it off."

Dieckmann also learned that when the desk lieutenant sent Officer Frank Connors over to the lunch counter to arrest Hoffman, he couldn't find him. Connors left when a waitress told him, "Some drunk was here kidding that he killed someone." It was on his second trip that Connors found Hoffman and arrested him.

Hoffman appeared at his preliminary hearing without an attorney. Recognizing the gravity of the offense, Judge Dean Sherry appointed attorney Roland De Fere for the case. De Fere entered a plea of not guilty and then requested his client be placed under psychiatric observation until trial.

Friday, May 26, 1933: Psychiatrist H.F. Andrews declared Hoffman to be sane and competent to stand trial. Still insisting that he hang, Hoffman changed his plea to guilty to allow the court to set the degree of murder.

Judge Sherry listened to witnesses and had Hoffman's statement to Dieckmann read into the court record. Then Hoffman took the stand and calmly recounted how he killed McDonald.

Tried in the Victorian courthouse at 200 West Broadway, Henry Francis Hoffman was one of many who faced justice between 1888 and the late 1950s.

When the hearing ended, Judge Sherry told Hoffman to stand and face the court.

"Henry Francis Hoffman, you are guilty of second-degree murder, and it is the sentence of this court that you be sent to San Quentin Prison for the term prescribed by law," the judge declared. With that, Hoffman was sentenced to five years to life.

As Hoffman waited in county jail to be transferred to "the Q," he appointed himself as a judge and made himself available to preside over quarrels between inmates. In one case, a young man was accused of chiseling another inmate out of cigarettes. When the case was brought before "Judge" Hoffman, the self-appointed magistrate sentenced him to hang. Hoffman then fashioned a rope from bedsheets, threw it around the man's neck and hoisted him off the ground. Watching the man fight for his life made Hoffman squeal with delight. Had it not been for the assistance of other inmates in getting the man down, he, too, would have been killed.

# CHAPTER 13

# THE STRAW KILLER

Sunday, October 15, 1933, 9:00 a.m.: Seaman W.W. Hillman of the San Diego–based USS *Trenton* was horrified at what he had just lifted out of the waters of San Diego Bay. "My God, there's a body in this bundle!" he exclaimed to his fellow sailors.

Ed Dieckmann was at home when his phone rang. Harry Kelly commanded him to respond to the Merkely Funeral parlor at 3655 Fifth Avenue regarding the recovered body.

Dieckmann arrived to find Detective Sergeant Fred Lightner already there. Together with the coroner, Dr. Elliott G. Colby, the men cut through a gray blanket, tightly lashed with twine and rope. Under the body was a sailor's sea-bag, slit down one side. The top of the bag was handstitched and sealed with a piece of auto upholstery and spotted with white paint. Stenciled to the side of the bag was the name "A.B. Muste."

The cloth was finally cut free to reveal the mangled body of an elderly woman, approximately sixty-five years old. Her legs had been amputated at the hips and were missing. Her arms were tightly lashed to her torso with twine. The only clothing was a white undervest and a pink-and-white striped nightgown. Around her neck was a peculiar-shaped black necklace.

As the coroner began his autopsy, Lightner tasked Detective Nat McHorney with locating A.B. Muste.

The autopsy Dr. Colby conducted gave the detectives a clear picture of how the victim died. She had suffered six distinctive blows to the head, each of which broke the scalp; however, the cause of death was massive blood loss as she was being dismembered.

"How long do you think she's been dead?" Lightner asked.

"No more than forty-eight hours."

The bureau men knew if they were to solve the case, they'd first need to identify the victim.

Back at headquarters, the men combed through all missing person reports within the past few days. No one matching a description of the woman had been reported missing.

As law enforcement broadcast on the AM band of a radio anyone could possess, Dieckmann decided to use it for the department's benefit. Broadcasting a request for information on an old woman who wore a unique black necklace, he hoped that perhaps someone would know who the woman was yet hadn't discovered her missing.

By the time he became chief of detectives, J. Harry Kelly was the most experienced member of the SDPD and had been involved in some of San Diego's biggest cases.

En route back to his office, Dieckmann was notified that another bundle had been plucked from the bay by a boat crew stationed on the USS *Langley*. Grabbing a uniformed patrolman, Dieckmann hurried to the naval landing.

This time, the bundle was wrapped in burlap. Cutting open one end, a human foot fell out. As Dieckmann suspected on the drive to the landing, the bag contained the missing legs of the elderly woman.

McHorney's check on Muste discovered a sailor who recently had been discharged and was believed to be back in his home state of Ohio. McHorney patched a call to Muste's hometown of Elyria requesting officers verify how long he'd been home.

The radio broadcast caused the sole phone line into the Detective Bureau to ring off the hook. Several people drove to the morgue to view the body; however, no one could identify her.

Then came a break. Mr. and Mrs. Charles Rogers and A.R. Paine of 1746 B Street viewed the body and identified her as Mrs. Laura E. Straw, a widow and their neighbor.

Detectives drove to Straw's address at 1204 Eighteenth Street to find the house locked. Dieckmann forced open a side window and then slid inside the small two-bedroom home. The kitchen table was set, and food was still on it. He quickly located where the murder took place. Inside the first bedroom, he

discovered a blood-soaked mattress on the bed and blood splatter adorning the walls. Dieckmann gingerly stepped into the next bedroom and saw a man's hat on a chair and a box containing papers and letters. The bathroom was filthy except for the tub. Rags and children's dresses were strewn about the room. Running his handkerchief along the rim of the bathtub, Dieckmann could tell it had been cleaned.

Mrs. Rogers said Mrs. Straw was wealthy and owned several properties in town. She also lived with a man named Tommy; however, no one knew his last name, and he had very little interaction with the neighbors.

Rogers also stated Straw and Tommy had been inseparable, but recently, he had been gone for two months. When he returned, the two responded differently to each other and often quarreled.

Shortly before the bags were pulled from the bay, Rogers asked Tommy where Laura was. He answered, "She went to visit friends in the valley."

"When was this?" Dieckmann asked.

"Yesterday," Rogers answered. "And I'm sure he was here this morning because I saw a light on in the house very early."

Another neighbor reported seeing Tommy and Straw together on an evening walk on October 13. Unfortunately, she couldn't add anything else regarding Tommy.

Fingerprint expert Lloyd E. Miers was sent to the Straw home. In little time, he located latent prints on a coffee cup, a mirror and a water glass. "Maybe one of these can give Tommy a last name," Miers hoped.

As Miers looked for additional prints, Lightner searched the kitchen. The detective sergeant quickly located a toolbox under the sink. Holding up a bloody claw hammer and a coping saw, Lightner declared, "I believe we have the murder weapon."

Dieckmann was assigned to search the back rooms of the house. He silently wondered why anyone would kill an elderly woman and with such brutality. As he meticulously combed through the box of letters in the second bedroom, he found a pad of paper that had been written on with such force that he could see indented writing from the pages that had been torn away. Holding the pad up to the light, he could see "Chuck: Come on in. Play the radio. Harry is asleep in the front room." The note was signed "P."

Dieckmann shared his find with his boss. As they studied the notepad, they now had another angle to consider. Were they dealing with a gang? Perhaps Tommy wasn't a suspect but rather a victim. Would they soon find his body in the bay?

The search located several more letters. One of them was several years old and addressed to "Thomas M. Jones." Was this the Tommy they were searching for?

Back at headquarters, the dicks were met with a telegram from the chief of police of Elyria, Ohio. His officers had connected with A.B. Muste, therefore establishing an alibi for him outside San Diego. When questioned about his bag, Muste stated it had been stolen from him prior to his leaving town. He was cleared as a suspect.

Later that day, Dieckmann met with Abbie Becker, the daughter of Laura Straw. Becker stated she hadn't visited her mother in months, but she knew her mom always kept a large amount of cash inside the home. "She often had well over $300," Becker sobbed. "She just laughed me off when I told her to put the money in the bank."

Further questioning revealed Becker knew little of Tommy and had never heard the names "Chuck" or "Harry" mentioned by her mother.

The best break came from the ID Bureau.

Fingerprints, arrest reports and booking photos contained in the humble SDPD ID Bureau proved invaluable in some of San Diego's most baffling cases, including the Straw murder.

The name "Thomas M. Jones" and the fingerprints found in the home had been checked and were found to be the same as those of an ex-con named Tellie McQuate. McQuate had done time in the Ohio State Penitentiary. A nationwide teletype was sent out on McQuate.

Tests done on the notepad revealed more indented writing, including an address of Tellie McQuate c/o General Delivery, Los Angeles, California. There was no additional information on who Chuck or Harry or P. could be.

No fingerprints other than those of Mrs. Straw and McQuate were found in the house.

The next day began with a phone call from a used-car salesman. McQuate had approached him on October 14 with an interest in buying a Chevrolet sedan. The salesman said McQuate was a "quiet fellow" and didn't seem like someone who'd murder an elderly woman. McQuate was loaned the car to test drive for several hours. The salesman said he wasn't on duty when McQuate returned the car, stating he wasn't interested in buying it.

Detectives met the salesman at the car lot. When they examined the car, they noticed the rear seat cushions of the car were on the floorboards.

"Did the car come back like this?" Lightner asked.

"Yes."

As Lightner quizzed the salesman, Dieckmann searched the car. He located a small red stain on the carpet of the backseat. There were also several abrasions to the felt-lined door frame. The car was impounded for a more comprehensive examination back at headquarters.

Several days passed; rumors and vague tips sent the bureau men scurrying after false leads.

WEDNESDAY, OCTOBER 18, 1933: Photos of McQuate arrived from the Ohio state prison. Wanted fliers were quickly plastered across town and in the newspapers. Within minutes of the newspapers hitting the streets, George Henning, a taxi driver, came into police headquarters holding the photo of McQuate. Henning said on October 15 McQuate requested a ride to the city of Oceanside, 50 miles north of downtown. Once they reached Oceanside, McQuate ordered him to continue north to Los Angeles. In all, the ride was more than 125 miles.

Lightner and Dieckmann commandeered a car from the SDPD motor pool and headed north. They partnered with the LAPD to search the area where McQuate was dropped off but found nothing.

SATURDAY, MAY 26, 1934: McQuate was still at large.

Lightner and Dieckmann met in the bureau office to review what they had. Wanted posters had been sent out across the country for McQuate. Chuck, Harry and P. turned out to be kids completely uninvolved in the case.

"Ed," Lightner said. "I think McQuate is still in L.A. laying low. He knows he's wanted, so he's going to stay holed up until the heat is off."

Dieckmann agreed. "If he took the $300 Mrs. Becker mentioned, then he has some money to live on. Perhaps he's paying to stay somewhere and throwing in a little extra for them to keep quiet. Odds are he won't come up until he's broke."

As the men waited for a break, they took it upon themselves to search the rental properties Straw owned.

One was the home of her next-door neighbor Mrs. Rogers. Nothing incriminating was found inside the house. However, after cutting a lock off the entrance to the crawl space, they located an eighteen-inch-deep hole in the rough shape of a grave. After examining the dig, it appeared whomever dug the hole gave up when the dirt became too hard to penetrate with hand shovels.

"Is this crawl space usually kept locked?" Dieckmann asked.

Mrs. Rogers responded, "Yes. Mrs. Straw stored her gardening tools there, and she kept the key."

SUNDAY, MAY 27, 1934: LAPD officers K.E. Kurtz and R.W. Clark were on morning foot patrol in Pershing Square in downtown Los Angeles. They spied a neatly dressed man sitting alone on a bench. Next to him was a long, slender package. The man pretended to be reading a newspaper; however, the officers quickly realized he was spying on them.

"I wonder what he's up to," Kurtz asked his partner. "Let's give the once-over."

"What's in the package, buddy?" Clark asked.

"I'm sure I don't know," the man sarcastically replied. "It was here when I got here."

The officers opened the package and discovered a piece of a garden hose, eighteen inches long, loaded with leaden shot.

"So you know nothing about this?" demanded Kurtz. "How about we waltz downtown and let you talk to our robbery detail."

The man told LAPD detectives his name was Robert Clark and gave an address of 326½ South Main Street. The address was just a few blocks from police headquarters.

"Where did you get this blackjack?" the LAPD detective demanded.

"Well, I made it," Clark answered. "I'm behind in my room rent, and I made it with the intention of getting some money. I'm down to my last nickel."

"So you planned to slug someone and rob them?"

"Yes, sir."

"Have you ever done time?"

When the prisoner didn't answer, the captain of detectives ordered him to be taken to the ID Bureau to be fingerprinted.

"Wait," the arrestee said as he leaned forward in his chair. "I may as well come clean. If you print me, you'll rap to me right away. I'm wanted for murder. I killed an old woman in San Diego last October."

Dieckmann was on duty when news of the LAPD arrest came in. That evening, he, Lightner and Detective Harry Baugh took custody of Tellie McQuate at the South Hill Street jail in Los Angeles.

The arrest report reflected McQuate was calm and collected. He even jokingly asked the policeman if they had brought the rope.

MONDAY, MAY 28, 1934: McQuate was arraigned for one count of murder. Taking the stand in his own defense, the ex-con retold the story of the slaying.

"I met Mrs. Straw at the Plaza in May 1932 and went to live with her a few days later. I did odd jobs around the house, and she paid me for it. She was very good to me. Every few days, I'd find money under my plate at the breakfast table. Every time we'd go downtown together, she'd offer me money. At first, we got along swell. Then I went away for six weeks. When I came back, she accused me of being with another woman. How she knew that, I don't know, but she always nagged me about it. She kept wanting me to marry her and even said she would give me all her money. But I refused. I just wanted out."

McQuate continued.

"On October 8, we were at Mission Beach when I saw my other lady friend. Mrs. Straw saw us talking, and she began bawling me out. The fight continued even at home, and I slept in the front room. I got up that night to get a drink of water. When I stopped by her bed, she continued to bawl me out. I had been tacking down carpets earlier that day and had a claw hammer out. I picked up the hammer and hit her in the head a couple of times. I must have hit her harder than I meant to because she quieted down after I popped her."

"Did you sleep that night?" he was asked.

"Yes. When I woke up at ten, I realized she was dead, so I began to think of ways I could dispose of her body. I called a friend of mine who sells cars and told him I wanted to buy a Chevy, so he let me use one for the day. I drove around the backcountry but couldn't find a good place to leave her. So on October 12 or 13, I started to dig a grave under the neighbor's house, but I couldn't dig deep enough. Then on October 13, Mrs. Rogers asked where Mrs. Straw was. That made me nervous, so I had to come up with a different way of getting rid of her. I found that bag I put her body in inside a closet. It once belonged to one of the people she'd rented a room to. The bag I placed her legs in came from under the Rogerses' house. She didn't bleed much when I cut her up, but I scrubbed the bathtub anyway."

"So what happened then?" DA Whelan asked.

"On Saturday night [October 14], I borrowed a car and took the two bundles to the pier. I threw them into the bay, expecting them to sink, but they didn't. If I could have reached them, I would have pulled them out of the water, but I couldn't get to them. I was too nervous to go back home, so I went to a hotel to lay low. I went back to the pier the day the bundle was found, and when I saw all the cops, I went to a show. I watched the movie twice then came out and ate supper. I left for L.A. when I saw the newspapers had my picture plastered all over them."

"How much money did you get from the old lady?" DA Whelan asked.

"Two hundred fifty. I have sixty of my own."

The DA pressed on.

"So you killed her on October 8, and her dead body lay in the house for six days?"

"Yes, sir."

"And there was no odor?"

"No, sir," McQuate answered.

The DA stood and walked to the witness stand. "Why did you kill her?" he demanded.

Ex-con Tellie McQuate showed a remarkable lack of compassion for Mrs. Straw when he recounted his violent murder to news-hungry reporters. He'd come to regret it.

"I didn't intend to. I was mad at her and I picked up the hammer. I was sorry afterward."

Following the preliminary hearing, McQuate consented to a press interview. Dieckmann sat next to him as the convict recounted his evil deed.

"Didn't you feel bad about your crime?"

"Well, there wasn't any use. It was over and done with," McQuate answered.

"How about dismembering the body? That was hard, wasn't it?"

McQuate quickly answered. "No. It was a lot easier than I thought it would be."

"Didn't your conscience bother you afterward?" asked another reporter.

"Not much. It was just as easy as shaving, as far as my conscience was concerned."

FRIDAY, JUNE 1, 1934: The case of the *People of the State of California v. Tellie McQuate* began. McQuate had earlier stated he didn't want a lawyer and would plead guilty.

McQuate said, "I feel my time has come, so I am ready to pay the penalty."

With the DA seeking the death penalty and to avoid an insanity appeal later, Judge W.R. Andrews appointed Attorney Charles Donnelly to represent McQuate. Faced with a confession and overwhelming physical evidence, Donnelly began the bench trial before Judge Lawrence N. Turrentine with hopes of a second-degree conviction that would spare his client the noose.

The coroner was the first witness to take the stand. Dr. Colby testified to the terrible wounds and the condition the body was recovered in and why he didn't believe Straw had been dead longer than forty-eight hours when she was plucked from the bay.

Mrs. Rogers was next. She testified that on either October 12 or 13 she heard knocking noises under her house. Upon further questioning, she stated the noises were coming from near the front of the home where the grave was found.

Then came the used-car salesman, who testified about McQuate using the Chevrolet around the time Straw went missing.

Dieckmann was the only policeman to take the stand. He testified to observing a clean tub in an otherwise filthy bathroom, the bloody mattress and the stains on the walls and what he and Lightner found in the Chevrolet sedan.

After all of his boasting to the press, McQuate chose not to take the stand and testify on his own behalf.

Monday, June 4, 1934: Both sides had rested, and Judge Turrentine was ready to issue his decision. He first summed up the evidence and then described McQuate by stating, "We are dealing with a cold, calculating murderer. One who considers the life of no one but himself."

The judge then leaned forward in his chair and looked directly at Tellie McQuate. "Are you ready to learn your fate?"

Attorney Donnelly replied that his client was ready. The courtroom fell silent. Everyone in the room waited for the judge to speak.

"Tellie McQuate, I find you guilty of murder in the first degree. It's the sentence of this court that you be taken to Folsom Prison and hanged on August 10, 1934."

McQuate didn't flinch. As he exited the courtroom, he told a bailiff, "I'll never hang."

Three days later, McQuate was transferred to Folsom, but as soon as he arrived, he appealed his sentence and then applied to the governor's office for clemency. Both were denied.

Friday, May 24, 1935: As he made a slow, solemn walk to the gallows, McQuate turned to his executioners and asked that they release his arms. "I want to walk this alone," he said.

McQuate stood silent as the hangman placed a hood over his head and the noose around his neck. Twenty witnesses stood and watched as the trap was sprung. Seconds later, he fell through the trapdoor and then strangled on the rope.

# THE CHARACTERS

**JASPER L. "JACK" BERG:** A native of Montana and a veteran of World War I, Jack Berg served the SDPD from December 20, 1915, until he retired as chief of detectives on October 14, 1936. He was in failing health when, on September 11, 1942, he shot himself in the garage of his home at 4715 Thirteenth Street. He was fifty-three years old.

**MALCOLM H. BERRIE:** Detective Lieutenant Berrie served the SDPD from January 10, 1916, to January 2, 1933. He was head of the Robbery Bureau when he suffered a debilitating stroke in 1932. One year later, he shot himself four times in a garage. The wounds proved fatal. Lieutenant Berrie was fifty-eight years old.

**PAUL BRUST, MD:** Dr. Brust served the SDPD as its police surgeon from January 1, 1927, until his retirement in late 1946. In addition to his staffing the police ambulance, every officer on the SDPD during the Brust era learned first aid from him. He died in December 1959.

**ALBERT J. CARSON:** In his lifetime, Detective Sergeant Albert Carson was a former pitcher for the Chicago Cubs, a veteran of the Spanish-American War and even a guard on Alcatraz. He joined the SDPD on February 14, 1914, and served until September 1, 1939. He passed away in 1962 at the age of eighty.

**RICHARD CHADWICK SR.:** The first of three generations of SDPD officers, Richard Chadwick was the father of famed swimmer Florence Chadwick, the first woman to swim the English Channel. Chadwick began his career on horseback as a mounted officer on November 14, 1910. He retired as a detective sergeant on July 1, 1931, and died on November 3, 1951.

**JOHN W. CLOUD:** A landmark figure in SDPD history, Cloud was hired as a chauffeur in 1918 but transitioned into the sworn ranks and eventually became the SDPD's first black sergeant. He supervised white officers at a time when black Americans in the U.S. military could only serve as cooks and stewards.

**ARTEMAS I. COMSTOCK:** A career motorcycle policeman, "Archie" Comstock began his career on January 10, 1916. He was promoted twice in his career, to sergeant and then lieutenant; however, he never left the motorcycle squad. He retired on July 1, 1939. He died at the age of eighty-four on September 15, 1966.

**EDWARD A. DIECKMANN SR.:** Hired as a detective on May 16, 1931, Dieckmann spent his entire career in the bureau. Promoted to detective lieutenant in 1936, Dieckmann spent the remainder of his career as the head of the Homicide Unit. He retired on April 1, 1954, and died on November 25, 1973.

**JOSEPH V. DORAN:** Minus a brief absence for World War I, Doran served the SDPD from January 10, 1916, until September 25, 1945. In 1927, Doran served as chief of police for two years. As chief, Doran reorganized the Detective Bureau into divisions, including Robbery, Homicide, and the Morals Squad (Vice). He retired as a captain. Doran died on May 14, 1950.

**PAUL J. HAYES SR.:** The first of three generations of SDPD officers, Paul Hayes began his law enforcement career as an SDPD patrolman on January 23, 1911. He became a member of the bureau when he was appointed as an inspector of lost and stolen property on July 30, 1913. He retired on June 15, 1931, as the chief of detectives. He died on March 10, 1947.

**JOHN A. KANE:** A navy veteran who saw combat in both world wars, Kane balanced his career between the uniformed patrol division and the bureau. He served the SDPD from June 4, 1923, until he left to serve in World War II in 1943. Lieutenant Kane died on March 27, 1977.

**HARRY J. KELLY:** The second son of an Irish blacksmith, Harry Kelly served the SDPD from December 20, 1915, until his retirement in 1943. Kelly spent the majority of his career with the Detective Bureau and held every rank, including chief of detectives. In 1939, he served as chief of police for ninety days. He retired to Berkeley with his wife, Julia. He died on February 4, 1955.

**FRED E. "JERRY" LIGHTNER:** A retired U.S. Navy boatswain's mate who saw service in World War I, Detective Sergeant Lightner served the SDPD from June 4, 1923, until his unexpected death from pneumonia at the age of fifty-one on September 21, 1937. He was the head of the Homicide Unit at the time of his passing.

**ALVIN W. LYLES:** A decorated veteran of World War I, Alvin Lyles served the SDPD from January 1, 1921, until February 2, 1941, when he retired with the rank of lieutenant. As he was one of San Diego's best-known policemen, news of his sudden death on February 6, 1952, at the age of fifty-four stunned the community.

**WALTER J. MACY:** Hired as a clerk for the Identification Bureau on January 1, 1914, Macy weaved his career between sworn and nonsworn ranks until he left the SDPD on January 1, 1943, to serve the United States Navy in World War II. Macy died on August 30, 1969.

**NATHANIEL McHORNEY:** The last chief of police for the city of East San Diego Police Department, Nat McHorney became a San Diego policeman when East San Diego ceased to exist in January 1924. With an expertise in murder investigation, McHorney served as a detective until his retirement in 1940. He died in 1956.

**STEWART P. McMULLEN:** Stewart P. McMullen served the SDPD from October 9, 1917, until April 8, 1919. His entire time in the police department was as chief of police. In 1923, he was elected to the San Diego City Council and later to the county Board of Supervisors. He died on August 23, 1954.

**WILLIAM A. MENKE:** ID Bureau superintendent Menke served the SDPD from October 16, 1917, until August 12, 1946. Originally hired as an ID Bureau clerk, Menke obtained donations of cameras and microscopes and helped establish one of the most modern crime laboratories in the United States at the time. He died on September 20, 1951.

**JOSEPH E. MYERS:** The life of Joseph Myers is as colorful as the man himself. Hired as detective on August 3, 1908, to join the newly formed bureau, Myers served the SDPD until he became the chief of police of the Coronado Police Department in 1922. He then continued his police career as an investigator for the district attorney's office and served a stint as the city marshal of Oceanside. He died on November 30, 1933, after he lost his foot to an infection.

**ROBERT P. NEWSOM:** Hired in 1916, Robert Newsom was one of eleven appointments to the office of chief of police between 1930 and 1940. That George Sears served five of those ten years speaks to the volatility of the office at that time. Newsom was a captain when he died on duty in his office on February 11, 1936.

**JAMES A. PATRICK:** Hired by SDPD on January 15, 1912, James Patrick was a veteran of the Spanish-American War and served three terms as chief of police. One of those, from 1919 until 1927, was (at the time) a record tenure for SDPD's top office. He finished his career in 1932 when he retired as the assistant chief of police. He died on January 16, 1960.

**JOHN T. PETERSON:** Only two men have ever served as SDPD chief of police on three occasions. James Patrick was one and John Peterson the other. Hired on March 11, 1912, "Pete" retired on March 20, 1940. Pete later said he hated the politics of SDPD's top office, and his favorite assignment was patrol lieutenant at the East San Diego substation. He died on March 23, 1947.

**HARRY J. RAYMOND:** A seasoned detective who served a twenty-year career in Los Angeles prior to venturing south, Harry Raymond only lasted as SDPD's chief of police from June 5, 1933, until September 1, 1933. Upon returning to the city of angels, Raymond made a number of enemies as a private investigator uncovering civic corruption. In 1938, he was the victim of a bombing when his car exploded with him in it. He survived, and his testimony saw ten members of the LAPD sent to prison, the chief removed from office and Mayor Frank Shaw recalled. Harry Raymond died on April 4, 1957. Weeks before his death, Raymond was arrested in downtown San Diego for vagrancy. The arresting officers had no idea who he was.

**THOMAS E. REMINGTON:** Hired as a motorcycle officer on June 16, 1926, Remington served his entire twenty-year SDPD career in the saddle of his Harley Davidson. He retired as a motorcycle sergeant on June 1, 1946. He died on April 1, 1977.

**HUGH B. ROCHEFORT:** A veteran of the army who served in the First World War, Detective Sergeant Rochefort served the SDPD from October 20, 1920, until October 21, 1940. He retired with a perfect record of never having missed a day of work. He died on May 2, 1978, at the age of eighty-eight.

**GEORGE M. SEARS:** Hired on January 27, 1915, Sears worked his way through the ranks, spending most of his time as a detective. In the early 1930s, Sears was a lieutenant, and his officers spent the majority of their time enforcing liquor laws. Known as the "Dry Squad," the five-officer team led raids on speakeasies and distilleries around the city. Sears was appointed chief of police in 1934 and served until his retirement on June 27, 1939. He died on March 28, 1974.

**MAURICE "MIKE" SHEA:** A veteran of World War I, where he served the U.S. Navy as a chief warrant officer, Mike Shea was hired by the SDPD on December 7, 1926, as a detective. Later promoted to detective sergeant, Shea became famous for raiding illegal alcohol distilleries during Prohibition. He was called up for World War II on March 6, 1942. He returned to the SDPD in 1945 and then retired in 1946. He passed away on December 15, 1968.

**REGINALD S. TOWNSEND:** Hired as a detective on January 1, 1915, Reggie Townsend was the second black officer to ever serve the SDPD. He made a name for himself cleaning up the Stingaree; however, his skills as a homicide investigator were second to none. Racism of the time led to his firing in 1919. He died on October 4, 1947, at the age of sixty-eight.

**WALTER A. WEYMOUTH:** Hired as a detective on January 1, 1915, the promising career of Walter Weymouth was cut short due to a devastating injury. Despite assurances of his impending death, Weymouth made a miraculous recovery and went on to serve the Bureau Investigation (the predecessor to the FBI) during the 1920s. He died just twenty days after his partner, Reggie Townsend, on October 24, 1947. He was sixty-four years old.

**GEORGE W. WILSON:** Hired as a patrolman on May 28, 1909, George Wilson was a veteran of the Spanish-American War when he took to the streets of San Diego. His entire career was spent in patrol as both an officer and a two-striped corporal. He retired on July 1, 1936, and passed away in his La Jolla home on November 24, 1950.

# BIBLIOGRAPHY

## Chapter 1

Castanien, Pliny. *To Protect and Serve: A History of the San Diego Police Department and Its Chiefs, 1889–1989*. San Diego: San Diego Historical Society, 1993.
Hon, Katherine. "Biography: Walter Weymouth." sdpolicemuseum.com/walter-weymouth.html.
*San Diego Union*, November 10, 1912; March 16, 1916.
———. Obituary, "Townsend, Reginald." October 4, 1947.

## Chapter 2

Career Memoirs. "Harry J. Kelly." San Diego Police Museum Archives.
———. "Joseph Myers." San Diego Police Museum Archives.
———. "Paul J. Hayes." San Diego Police Museum Archives.
Casefile. McCrary Homicide. 187 PC. San Diego Police Museum Archives.
Census Report. San Diego, CA, 1910.
City Directory. San Diego, CA, 1916
*San Diego Union*, January 11, 1918; January 13, 1918.

## Chapter 3

Career Memoirs. "Edward Dieckmann." San Diego Police Museum Archives.
———. "Joseph Myers." San Diego Police Museum Archives.
Investigator Notes. "Henry Stevens; Miner Homicide." San Diego Police Museum Archives.
*San Diego Union*, May 16, 1918.

## Chapter 4

Career Memoirs. "George Sears." San Diego Police Museum Archives.
————. "Joseph Lopez." San Diego Police Archives.
————. "Richard Chadwick." San Diego Police Museum Archives.
San Diego Police Department Archives
*San Diego Union*, April 8, 1920.

## Chapter 5

Career Memoirs. "James Patrick." San Diego Police Museum Archives.
————. "Richard Chadwick." San Diego Police Museum Archives.
San Diego Police Department Archives.

## Chapter 6

Career Memoirs. "Harry Kelly." San Diego Police Museum Archives.
————. "Maurice Shea." San Diego Police Museum Archives.
————. "Paul Hayes." San Diego Police Museum Archives.
*Los Angeles Times*, January 6, 1927; March 30, 1927; August 24, 1927.
*San Diego Evening Tribune*, September 20, 1928; September 30, 1928.
*San Diego Union*, December 28, 1927.

## Chapter 7

Career Memoirs. "Paul Hayes." San Diego Police Museum Archives.
*San Diego Union*, January 13, 1927; January 14, 1927; January 15, 1927.

## Chapter 8

Career Memoirs. "Harry J. Kelly." San Diego Police Museum Archives.
————. "Nathaniel McHorney." San Diego Police Museum Archives.
*San Diego Tribune*, May 9, 1928.
*San Diego Union*, May 7, 1928.

## Chapter 9

Career Memoirs. "Edward Dieckmann." San Diego Police Museum Archives.
Crawford, Rick. "Heist on the Dike." May 2010.
Investigator Notes. "Harry J. Kelly." San Diego Police Museum Archives.

————. "Paul Hayes." San Diego Police Museum Archives.

*San Diego Union*, May 21, 1929.

*San Diego Union-Tribune*. "Gangland Ties Initially Suspected in Deadly 1929 Heist." December 13, 2009.

## Chapter 10

Career Memoirs. "Edward Dieckmann." San Diego Police Museum Archives.

Investigator Notes. "Jerry Lightner." San Diego Police Museum Archives.

*People v. Durborow*. 130 Cal. App. 615, 20 P.2d 708, 1933 Cal. App. LEXIS 1055.

*San Diego Union*, January 10, 1932.

## Chapter 11

Investigator Notes. "Jack Berg." San Diego Police Museum Archives.

San Diego Police Department Archives.

*San Diego Tribune*, August 2, 1932.

*San Diego Union*, April 5, 1933; October 3, 1933.

## Chapter 12

Investigator Notes. "Edward Dieckmann." San Diego Police Museum Archives.

*San Diego Tribune*, May 27, 1933.

*San Diego Union*, March 8, 1933.

## Chapter 13

Hon, Katherine. Biography. "Harry J. Kelly." sdpolicemuseum.com/Kelly.html.

Investigator Notes. "Edward Dieckmann." San Diego Police Museum Archives.

*Los Angeles Times*, June 5, 1934.

*People v. McQuate*. 2 Cal. 2d 227, 39 P.2d 408, 1934 Cal. LEXIS 488.

*San Diego Union*, October 16, 1933.

*Santa Ana Register*, April 16, 1935.

# ABOUT THE AUTHOR

A San Diego resident since 1977, author Steve Willard joined the SDPD in 1985 and has worked patrol, crime prevention/public affairs, the Detective Bureau, the Traffic Division and management. He became a charter member of the San Diego Police Museum in 1997, and in 2013, he was selected to be the historian of the San Diego Police Officers Association.

With a grandfather who was a fire chief and a father who served forty-four years in law enforcement before his retirement as a police chief, he's the third generation of his family to serve in the EMS field.

A recurring columnist in two law enforcement periodicals, Steve has also authored three books on SDPD history and has consulted on a number of other historical projects.